DARING ADVENTURES IN PAINT

FIND YOUR FLOW, TRUST YOUR PATH,
AND DISCOVER YOUR AUTHENTIC VOICE

TECHNIQUES FOR PAINTING, SKETCHING, AND MIXED MEDIA

Mati Rose McDonough

Quarry Books
100 Cummings Center, Suite 406L
Beverly, MA 01915

quarrybooks.com • craftside.typepad.com

First published in the United States of America in 2012 by
Quarry Books, a member of
Quayside Publishing Group
100 Cummings Center
Suite 406-L
Beverly, Massachusetts 01915-6101
Telephone: (978) 282-9590
Fax: (978) 283-2742
www.quarrybooks.com
Visit www.Craftside.Typepad.com for a behind-the-scenes peek
at our crafty world!

10 9 8 7 6 5 4 3 2 1

ISBN: 978-1-59253-770-9

Digital edition published in 2012
eISBN: 978-1-61058-415-9

Library of Congress Cataloging-in-Publication Data

McDonough, Mati Rose.
 Daring adventures in paint : inspiring techniques with collage and mixed media / Mati
Rose McDonough.
 p. cm.
 Summary: „Daring adventures in paint is a colorful, whimsical adventure of a book that
explores inspirational paint and mixed-media techniques. Written by the well-loved
artist/illustrator/blogger Mati Rose McDonough, this book's approach to making art
is a bit like uncovering a hidden treasure, a treasure that resides within each aspiring
artist. Through a myriad of both practical applications and creative exercises, Mati shows
artists how to ‚find their magic'--the place of confidence from which they can access the
vision of what they want to share with the world"-- Provided by publisher.
 ISBN 978-1-59253-770-9 (pbk.)
 1. Collage. 2. Mixed media painting. I. Title.
 TT910.M33 2012
 702.81'2--dc23
 2011050787

Design: Nancy Ide Bradham, www.bradhamdesign.com
Layout: Laura H. Couallier, Laura Herrmann Design
Photography: Leslie Lindell, www.lesliesophialindell.com

Printed in China

To my amazing mom—
I love you.

Contents

Introduction

Daring to be messy, childish, silly, rebellious, authentic, happy, and brave! That's right, happy. It's daring to be happy and even to make wonderful, uncool, dorky art if that's what you want to do. It's equally daring to create potent, dark, and edgy art if that is your calling. Ultimately, it's daring to embrace your story and the bumpy process of creatively expressing yourself.

This is also a book about adventure and pushing outside of your comfort zone. I hope you'll paint big if you tend to paint small. I hope you'll use clashing patterns and colors. I encourage you to spill paint, get wet, and act like a kid on the first day of kindergarten, bursting with excitement and anticipation.

And maybe that's the bravest thing you can do—let go of the concept of doing something right and remember that there are no mistakes, only discoveries. And what a world to discover! I love leaving my studio and letting my neighborhood be my inspiration—the buildings, the people, the sky, the birds, graffiti, the ocean, the hills. They all speak to me and they show up in my work. That's my magic sweet spot. What's yours?

While this is a book about painting, it's secretly a book about discovering and being true to your creative, swashbuckling self. Be brave enough to paint the world from *that* place and to *find your magic,* big messes and all! I promise that this artistic freedom will impact your life because the risks you take on the canvas mirror how you live. So be brave, create from this place, and have fun!

— *Mati Rose McDonough*

Security is mostly a superstition. It does not exist in nature, nor do children as a whole experience it. Avoiding danger is not safer in the long run than outright exposure. Life is either a daring adventure or nothing.

— Helen Keller

7

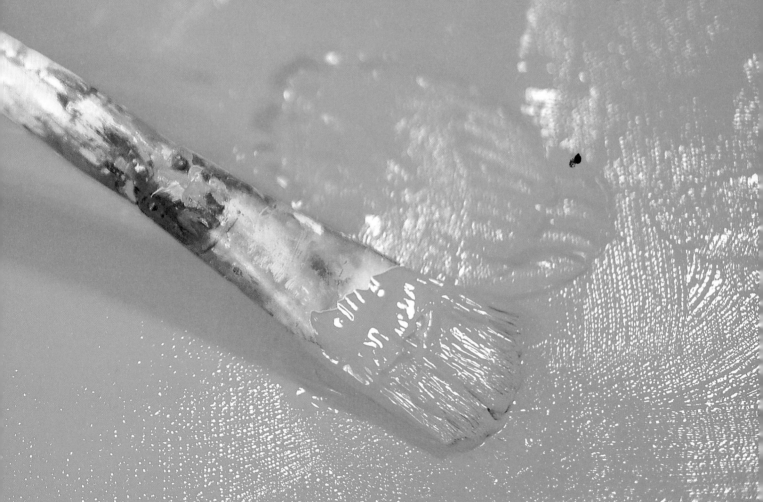

Beginning Your Journey

Finding Inspiration;
Creating Your Painted Background

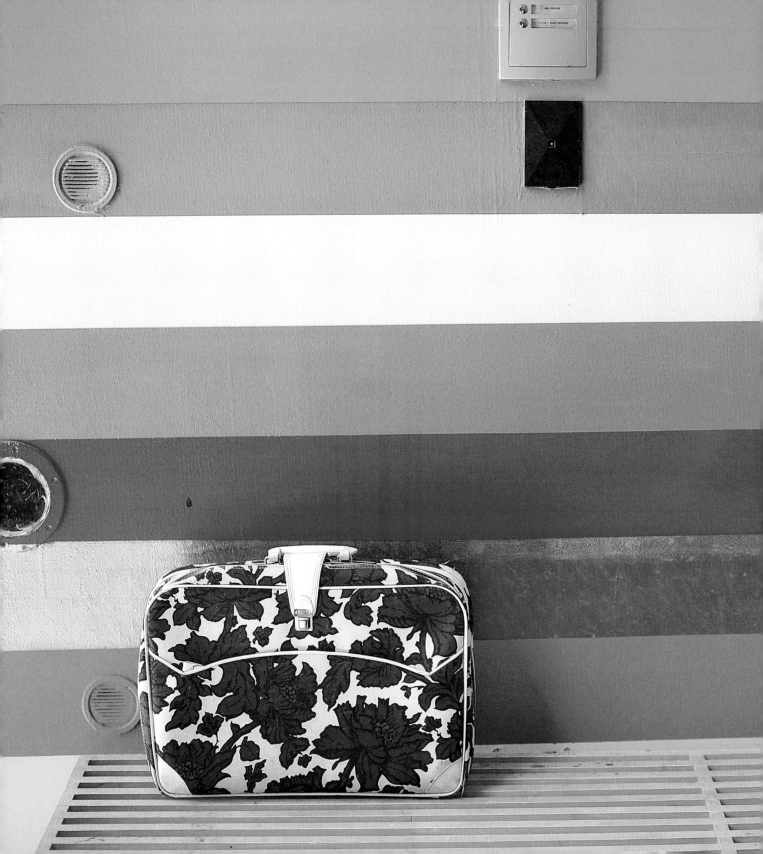

Getting Started

Here is where our voyage begins! By simply picking up this book you have planted one foot in the boat, grabbed an oar, and are on your way toward discovering your unique artistic treasure.

Everyone has a treasure inside of them—that rich place of true creativity and magic that can get lost or forgotten as we busily make our way through life. It's that wonderland of creative possibility that was alive when we were children, and that wants to be rediscovered through play, curiosity, and delight.

In this book you will find practical and daring painting, mixed media, and collage techniques, as well as ways to help support and inspire you as an artist. At least half of the artistic journey is achieved through nourishing your inner artist and developing an artistic practice that suits you. I will share the practices that have helped me remain open to inspiration, while keeping the critics at bay. My hope is that these practices will aid in your search to discover your artistic voice and unearth more of your hidden treasures.

You have no idea what you'll discover in this process. What you do will not look like what I do or what anyone else does. What you make will come from what you see and what you love. Art making can heal your wounds and open your heart. So stay open and keep an eye out for the hidden treasures in your midst—the light as it comes into your kitchen, the beauty of falling leaves, steam rising from a pond in the early morning— whatever you see, pay attention, and follow it. That's the treasure speaking to you. I believe that that which you paint, is a mirror for how you can live your life.

Let us use the metaphor of a seafaring voyage as we begin this book. I will be your shipmate on this creative journey, guiding you with hand-drawn maps, inspiration, and encouragement.

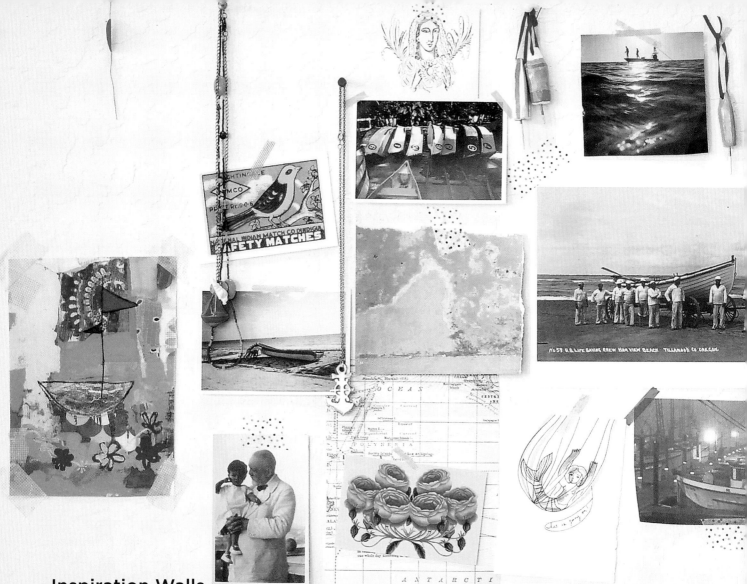

Inspiration Walls

Gathering inspiration is a natural part of the
creative process. Starting out, it's helpful to pick up
a few books and magazines that inspire you; maybe
an old children's book or a fashion magazine. It's
encouraging to surround yourself and your space
with inspiration. Create an inspiration collage on the
wall culled from magazine clippings, paint swatches,
and perhaps a fabric scrap that calls to you to help set
the tone for your creative journey ahead, especially
when you're stuck.

With thumbtacks and colorful Japanese washi tape
(found in Japantown in San Francisco, but available
in many art supply stores or online), I combined
necklaces, postcards, maps, vintage photos, maga-
zine clippings, photographs of boats from a past
trip to Mexico, a pretty letterpressed business card
that was in my pocket today, and buoys that my dad
carved and painted when he was a boy with his great-
grandfather during summers spent in Nova Scotia.

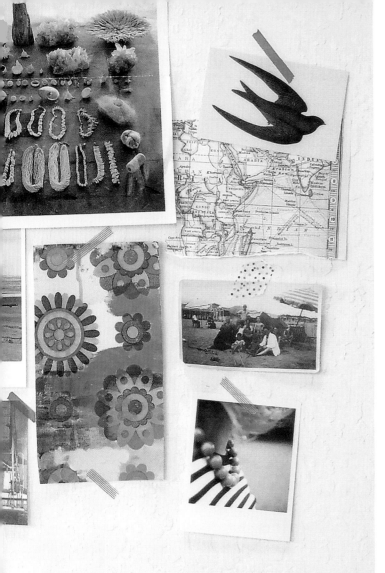

A Daring Adventure in Inspiration

You don't have to spend money to be inspired; I incorporate collage elements directly from walks in my neighborhood, my recycling bin, and junk mail. Find inspiration in ordinary objects: colorful scraps of paper on the ground, fruit stickers, pat-terned insides of envelopes, fabric, feathers, leaves, and letters.

Take a walk and try to incorporate bits of your surroundings into your inspiration wall and then, later, a painting.

- *Notice your current surroundings and what colors leap out at you.*

- *What other places inspire you that may be within reach? What inspirations arise from your memories or photos?*

My touchstone places of inspiration are Bernal Hill, Berkeley Marina, Chinatown, the Mission District, flea markets, thrift stores, dollar stores, Maine, Mexico, Italy, the ocean, the farmer's market, and friends' studios. I'll share some of these places with you later in this book!

Inspiration Inventory

Take stock of what inspires you, and create an inspiration inventory in your sketchbook for future reference.

Jot down free-form what inspires you visually.

Items that inspire me: vintage silk scarves, both real and fake flowers made from silk, felt, sequins, paint colors, big rings, seashells, old books, necklaces, layered colors, peeled paint, garlands, bikes, handwritten signs, gardens, colors of San Francisco houses, thick lattes, and berry pie.

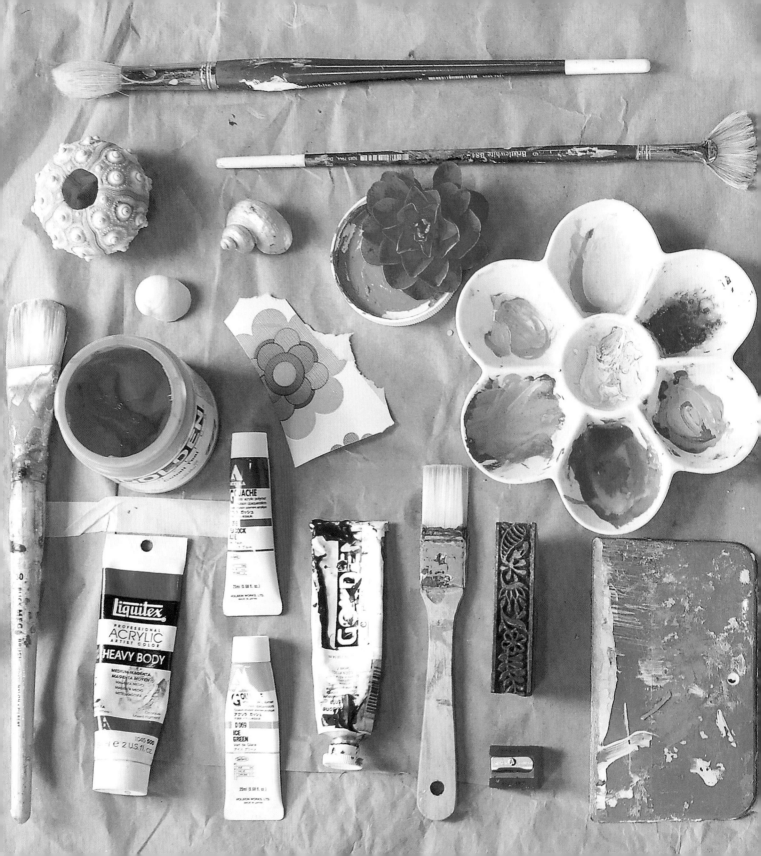

Essential Materials

This section includes what have become my favorite, tried-and-true materials after many years of painting and trial and error. You may have preferences already, or you will start developing them along the way. These are just suggestions. I encourage you to use what you already have on hand. Start with some basics, and add more to your arsenal over time.

Surfaces

Surfaces suitable for the exercises in this book include canvas, wood, Masonite, and paper. I mostly use wooden panels. They are affordable, available in almost any dimension, and ready to hang. Plus, they are usually pre-gessoed and ready to paint on. They are very durable for using multiple mediums and endure pressure and sanding.

Alternatively, the nice thing about painting on canvas (as opposed to wood) is that it offers more "grip" for the paint, since it is more textured. I vary my surfaces from piece to piece according to what I have on hand and feel like using at the moment.

Experiment with different surfaces to see what works best for you.

1 Creating a Rich Background

KNOW THAT THIS PROCESS IS EVOLVING *and is full of twists and turns. Know that there are no rules or mistakes. This is merely a guide for you, a starting point where you can begin to create.*

Materials

- surface for painting on
- acrylic paint, especially titanium white
- palette surface

Tools

- hair dryer or heat gun
- large brushes
- container for water
- palette knife
- brayer
- squeegee or sample credit card
- sandpaper

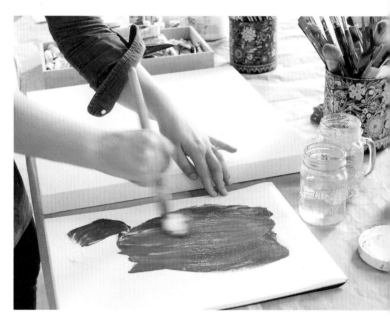

STEP 2

With a wet brush, begin to mix the colors together into a thick pool. Mix them about 75 percent together so that there are still unexpected variations within the colors. I don't use very much water in this mixing stage because I like the consistency (water breaks down the compounds in the paint). Experiment to find the consistency you like; there are no rules. You may also notice that I mix in a very wide space using up an entire palette—this is just so that I feel free and loose. You can scrape the colors together in a smaller pile with a palette knife at any time.

STEP 1

A blank canvas can be intimidating! Start off by picking any color, and then choose analogous (similar) colors that are in the same color family of either warm (think fire) or cool (think water). I chose magenta, pink, orange, and red. For cool colors, try blues and greens. Also try adding titanium white to make the color more interesting and opaque.

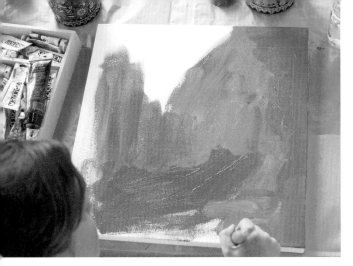

STEP 3

Using a big brush, cover your entire canvas with this lush first color.

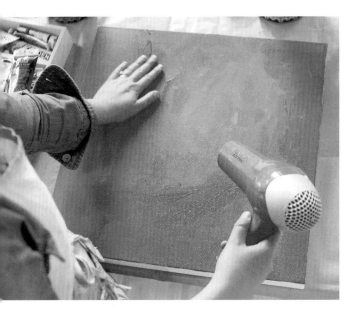

STEP 4

Dry layers with a hair dryer in between applications to speed up the process—acrylic is great to work with because you can build up layers quickly. You can also work on multiple canvases at a time and switch back and forth between them as they dry.

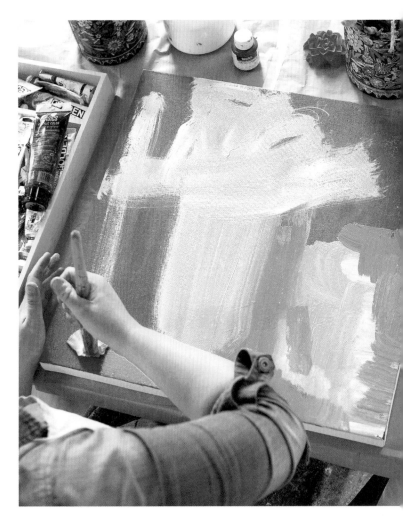

STEP 5

Paint over the canvas with a second color: for example, turquoise. (If you started with cool colors, choose warm colors for this layer.) Mix this color in the same fashion, using several analogous shades plus titanium white, leaving some variation in the color. Layering these colors helps to add immediate depth to your painting. Also, it's helpful to think about using contrasting colors. Cool turquoise makes a warm red pop! Think about varying your brushstrokes and allow bits of the red to shine through.

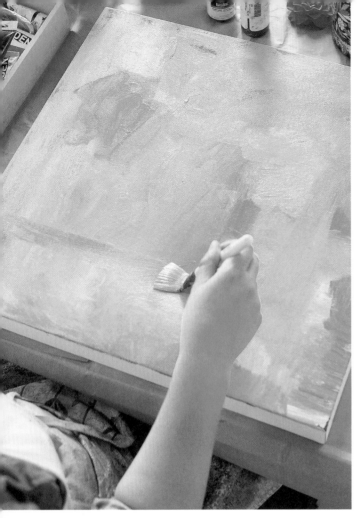

STEP 6

Now you should be loosened up and have some rich color and texture to play with. It may already be a beautiful painting, and perhaps you'll want to stop right now and call it finished, like Rothko with his luminous layers of color.

STEP 7

This is a good time to paint the edges of your canvas with one of these base colors. This is what I do, though some people elect to leave the edges raw or paint them at the end. It's your choice.

Four Foundational Techniques: Brayering, Squeegeeing, Dry Brushing, and Sanding

Here are some additional fun, fast, and easy ways to build layers in your paintings. By using each of these methods, I really enjoy how unexpected and daring it feels to boldly cover a painting in big swoops of paint.

Using the same turquoise painting shown earlier, I'm going to show you how you can continue to build on the same canvas using all of the painting techniques throughout this book, shown in chapter 8. This prospect in itself is an adventure, for I have no idea how it's going to turn out in the end. This painting will surely have some chaotic phases to work through. I hope you will enjoy seeing the painting evolve through all these stages in chapter 8 at the end of the book.

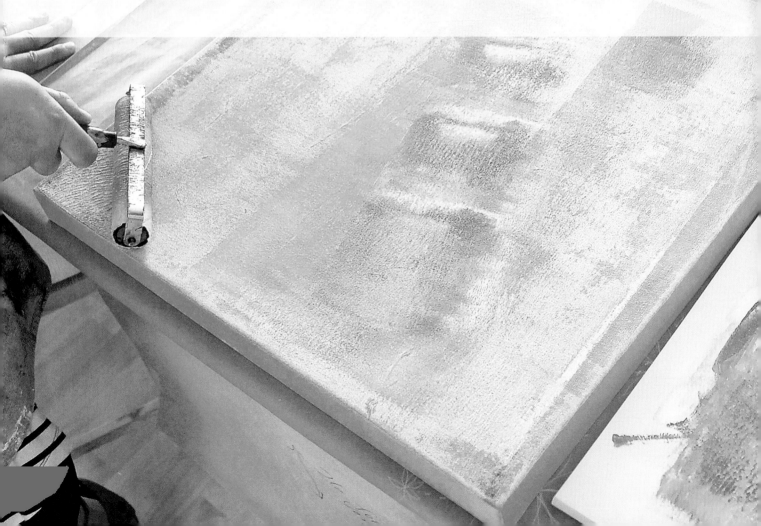

TECHNIQUE 1: **Brayering**

Brayers are traditionally used in printmaking, but they can also be used for painting. Put a couple of colors on your palette—orange and titanium white are shown here, mixed together for a cantaloupe/tangerine color. Roll the brayer directly into the colors to mix them, and then start rolling the brayer on top of your canvas. The first mark is thrilling to notice against the contrast of the turquoise base. You can still see hints of red peeking through, too.

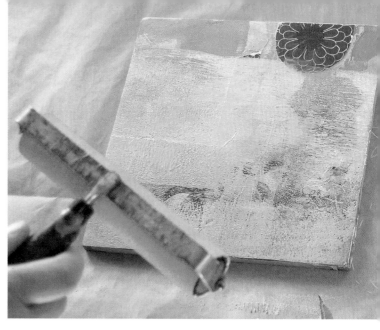

I like the look of the orange paint against the turquoise and how it matches the collage elements underneath, but I have completely obscured this beautiful paper.

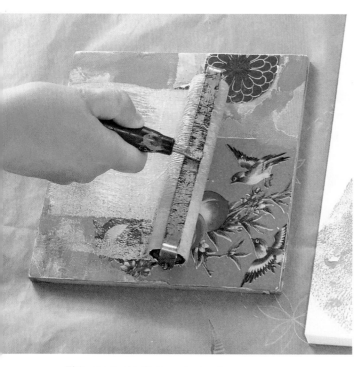

This example demonstrates how you can use a brayer in the same fashion, but with a different painting that is further along in the process and that has a collage on it.

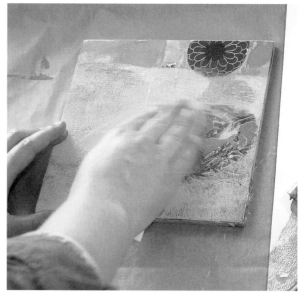

Fortunately with acrylic paint you can simply wet a rag or paper towel and wipe your paint off to reveal parts of the underlying layers.

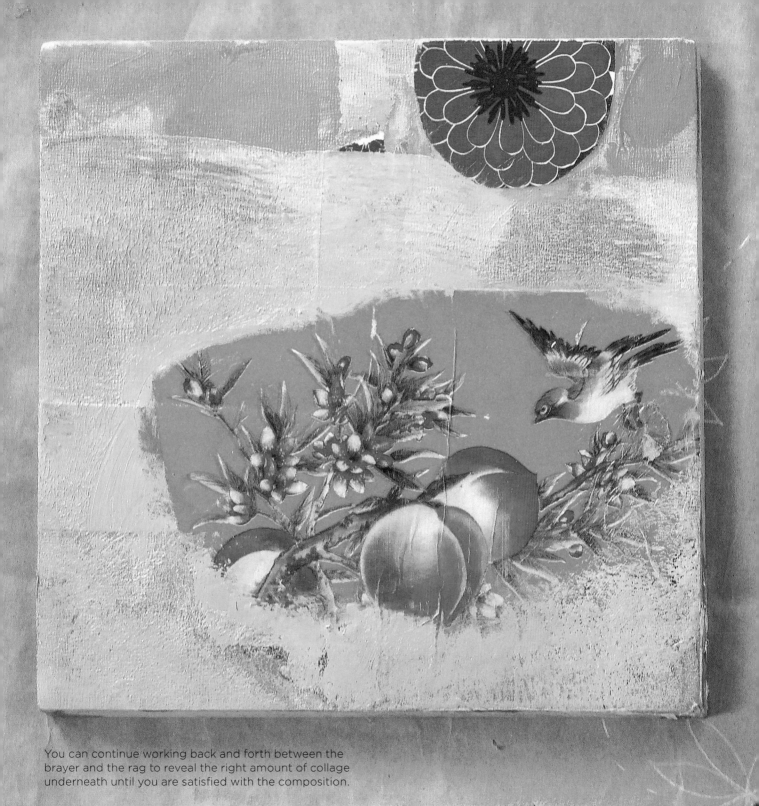

You can continue working back and forth between the brayer and the rag to reveal the right amount of collage underneath until you are satisfied with the composition.

TECHNIQUE 2: **Squeegeeing**

I also discovered this technique while learning printmaking. Traditionally, you use a squeegee to pull a print over a silkscreen. I like using a squeegee when I'm painting to create additional texture, and when I'm mark making to resemble screen printing. Squeegees are inexpensive, but if you don't have one or don't want to purchase one, you can substitute an old or sample credit card to achieve the same effect.

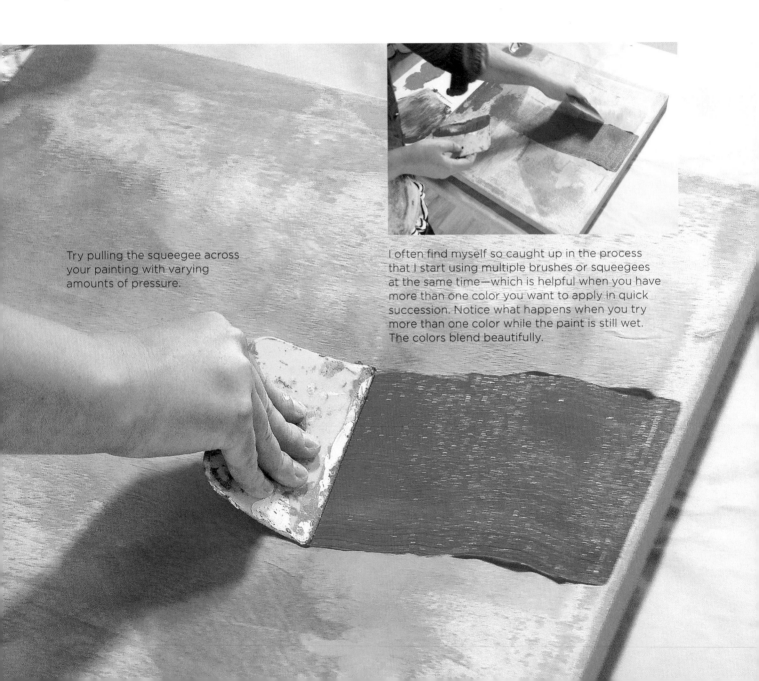

Try pulling the squeegee across your painting with varying amounts of pressure.

I often find myself so caught up in the process that I start using multiple brushes or squeegees at the same time—which is helpful when you have more than one color you want to apply in quick succession. Notice what happens when you try more than one color while the paint is still wet. The colors blend beautifully.

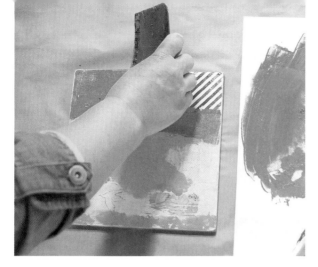

In this painting, I want to cover this distracting striped pattern but still keep it slightly visible. I rotated the painting and pulled the squeegee across.

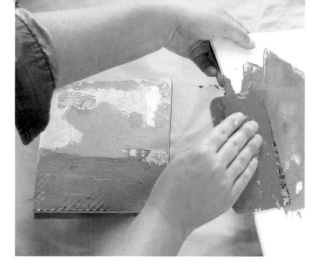

Since I put too much paint on my squeegee, I'm using the side of my palette to scrape some off. I then run the squeegee across the painting again to pull off some paint and make the striped paper slightly more visible.

A squeegee can also be a mark-making tool for making straight but nuanced lines. Try holding the squeegee upright and running it across your painting.

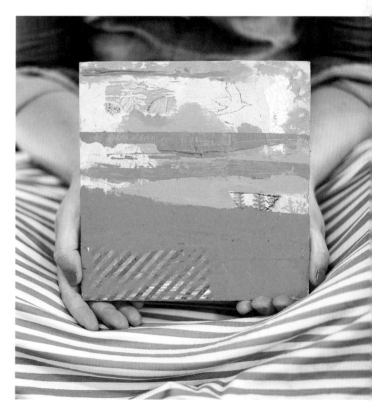

TECHNIQUE 3: **Dry Brushing**

This technique is exactly what it sounds like and simply means choosing a dry brush (one with no water or paint on it), dipping it directly into the paint, and dragging it across the canvas. It creates a nice effect because the paint lies more loosely on the top of the canvas versus sinking into the tooth of the canvas. This layer of paint stands out against the multiple layers of paint beneath it. On my primary canvas, the dry brushing is done with the white paint since there are so many layers already.

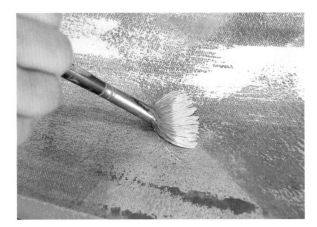

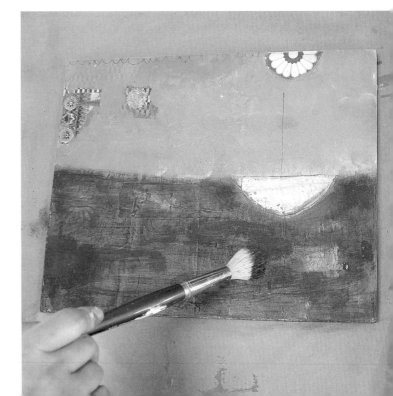

It is easy to see the effect of dry brushing on the ocean portion of this in-progress painting (right). By using a dry brush, I'm able to maintain the subtle color of blue underneath, even though I'm going over it with a deep blue on top.

TECHNIQUE 4: **Sanding**

Gently sand paint layers to scratch in texture.

The effect is much more dramatic on the previously shown ocean painting which was done on wood. I especially appreciate this technique when working with themes such as this one because it evokes the feeling of being weathered by the sea and dried out by the sun, like driftwood.

Again, the effect of sanding is subtle in my original painting because of all the preexisting colors and textures, yet it still adds a texture to the surface. Note: Remember that you don't want to sand too much on canvas because it can result in a threadbare surface (as I've learned from experience).

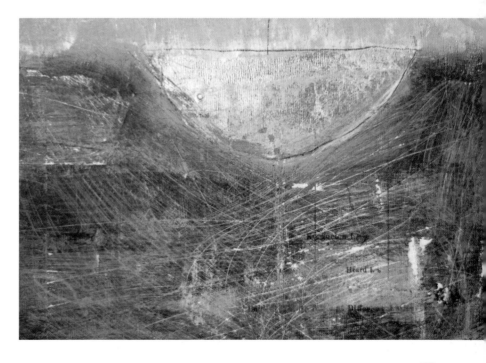

Location Inspiration: Maintaining an Adventurous Art Space

Here's a view into my evolving studio space. It ebbs and flows between being tidy and being chaotic, depending on how much I have on my plate. It's a delicate creative balance to maintain a space where you're visually stimulated and yet not overwhelmed. I enjoy taking the time to clean and organize between projects and paintings, yet I often make the best discoveries when I don't and happen upon surprising juxtapositions of objects or colors that spark ideas for new work.

I love being surrounded by collections of color, pattern, texture, and scale to maintain a playful and engaged frame of mind. Some of the treasures that keep me inspired as I work are little dolls, a sea urchin, my turquoise-shade ring collection, a medicine bottle (unearthed behind my mom's house in Maine), and blossoms from outside my studio.

Regardless of where you create, good lighting is ideal and makes a difference in how you see color. I feel lucky to have a sunny space right now, but I have definitely created via moonlight and unnatural lighting.

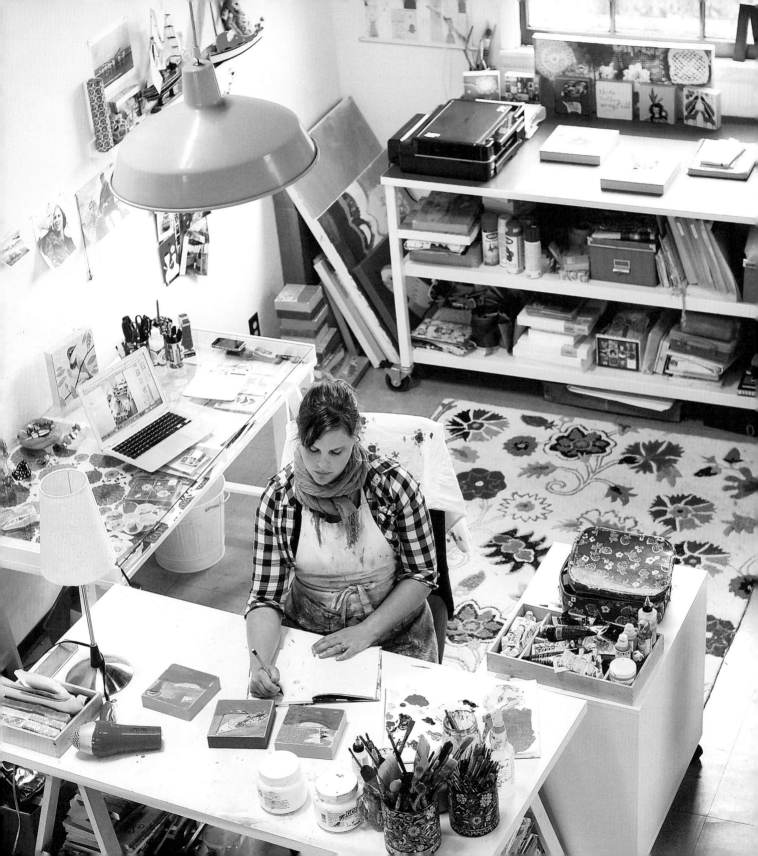

chapter 2

Navigating Your Route

*Trusting Your Path;
Creating a Patchwork
Paper Collage*

Trust Your Path

My path toward becoming an artist has not been linear. I feel like I've been climbing a mountain, but instead of going straight to the top, I've been traveling around it; stopping to camp, gathering provisions, skinning my knees, and getting lost. Wondering, is that the same tree? And am I even on the right mountain?

Your path will be completely unique to your particular journey. Embrace it for all its peculiar twists and turns. These diversions and missteps will all add color and personality to your art. This is where your adventure lies.

I sit today in my studio with a stack of journals and sketchbooks from over the past ten years of living in San Francisco. I want to look closely at where I have been and where I currently am, and to understand the steps that brought me here, where I am finally making my living as an artist.

I want to share this entry that I wrote ten years ago:

"I am one week away from my first art show and party. It will be a party and I will be an ARTIST! It will be OK. No, it will be beautiful. Well, it will be what it will be—a gathering of friends, good music, and food. I look forward to it and I am taking strides, wide leaps, and becoming Mati Rose ... it is certainly hard work."

It reminded me of how vulnerable I felt, stepping out as an artist with my first art show. It took me many years and a lot of practice to call myself an artist and to own that identity. I realize how intertwined this was with accepting the off-kilter journey that lead me to this place. The title of "artist" seemed so uncomfortable and unattainable to me. I had all these preconceived notions of who an artist should be. Artists have huge shows in fancy white-walled galleries, and they paint every single day in airy Manhattan lofts with fervor and vision! In particular, I believed that real artists never doubted their ability or ever lacked confidence. I never considered the long journeys taken by established artists to arrive at whatever point of their successes I was witnessing. It hadn't occurred to me that they too might have had a wobbly, nonlinear start!

So, rest assured that there will be moments of uncertainty ahead in your painting journey. Even today, after painting for the past decade, I sit in my studio and have difficult days when I feel like a fraud and my insecurities take hold. The first step toward conquering this feeling is to lean into the discomfort of uncertainty. Now I realize that this is just part and parcel of being an artist and creating something essentially out of nothing. We make it up and make it happen! This is where a bit of mapmaking helps me when I feel lost. It's grounding to have concrete goals and destinations!

Inspiration Inventory

Another trick for categorizing inspiration and to really see the themes you are drawn to is to store your scraps and clippings in a binder in plastic sleeves. This is a simple idea, but it has done wonders for me in being able to quickly pull from different palettes and motifs. I have different binders labeled "Textiles," "Color," "Fashion," and straight up "Inspiration" that I can pull from when creating a new body of work.

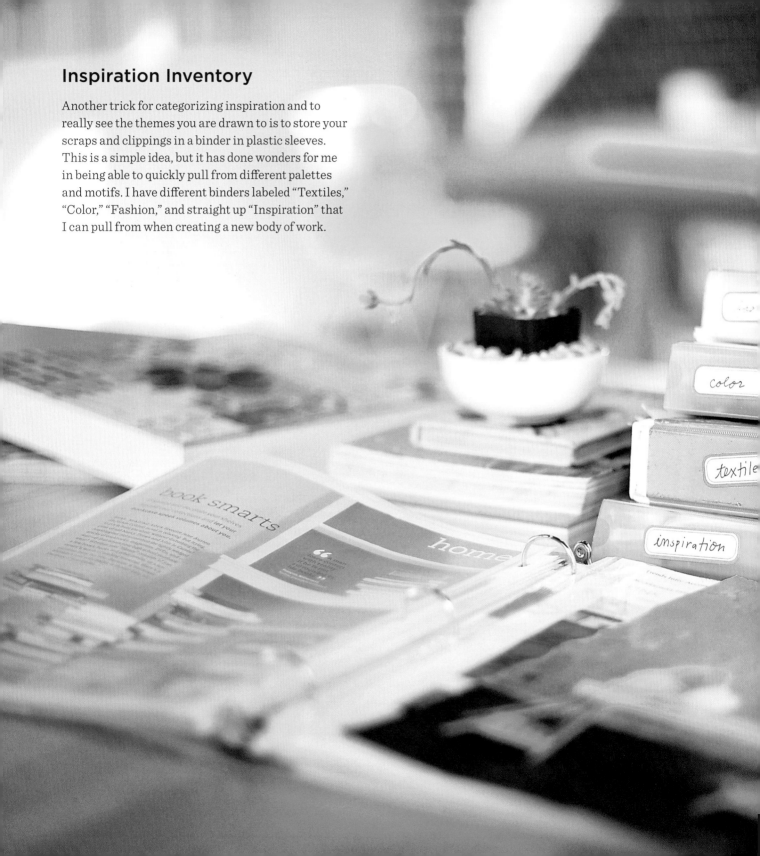

Map Your Artistic Route

How do you get where you want to go? It's important to ground your ideas with goal setting. Some people have the idea that an artist's creativity comes from pie-in-the-sky inspiration. The most amazing artists I know utilize both the left and right sides of their brain to explore new territory. They use the creative side of their brain to spark new ideas and the analytical side to ground their ideas in action. For me, my ideas come in fleeting bursts, and I need to write them down to capture them, make connections, and take steps forward.

I've also learned that in my personal art practice, it's necessary to quantify what I'm doing if I want to push myself further. So, what is your artistic goal? Is it to paint ten paintings? Have a gallery show? Paint a painting for your home? Develop better paintbrush skills? All goals are valid; the important part is setting the intention for where you want to go and having the ability to visualize it happening. Visualize a beautiful painting on your wall with your name on it—just like we did in chapter one by visually laying out inspiration to inform our art. Let's visualize where we want to go artistically!

- *What are your art goals for today? Next week? In one month? In six months? How about five years from now? Don't overthink them! Just write down the juiciest ones.*

- *How will you get where you want to go? (I'd like to go by boat, please!)*

- *What's in your treasure chest awaiting you?*

Draw out your own map in whatever style makes sense to you … with paint or pencil, or maybe by setting up another visual scene of your favorite collections on your shelf.

Sketchbook Reflections

Write down some of the feelings you'd like your art to evoke.

Some of my words are:

Happy

Playful

Lush

Beautiful

Quirky

Layered

2 Creating a Paper Collage

IN THIS EXERCISE I WANT TO INTRODUCE COLLAGE *and how to make a patchwork collage similar to a quilt. We will use scissors, but you can use free-form ripping for a more organic look. This is a great exercise to get your creativity flowing and make exciting connections that you might not have made if you approached a blank paper with paint. New color combinations, patterns, and imagery mix in unexpected ways to create sparks on your canvas. This is also a great way to use bits and pieces of ephemera that you may come across in your daily adventures!*

Materials

- paper
- gel medium
- surface for collage

Tools

- scissors
- craft knife

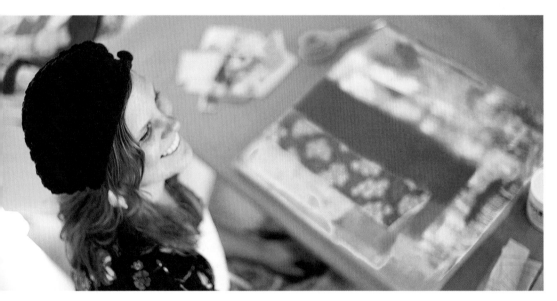

Patchwork Past

In making my patchwork collages, I feel connected to my roots and the heritage of quilters before me. Quilting provided comfort for pioneer women during their journeys westward and brought cheer during the dark days of the Depression. Quilts continue to serve as a way to make us feel comforted; not only by their physical warmth, but also in the way they tie together memories through remnants such as an old dress, baby clothes, or your mom's curtains. The community aspect of quilting bees and women gathering over a sewing table has a strong narrative element; sharing fabric and stitching is very healing for our journeys.

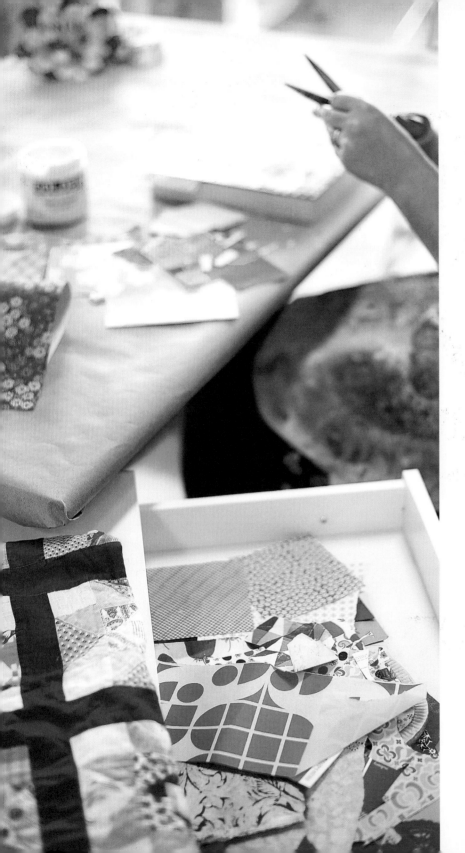

Artist Admiration Related to Patchwork Collage

- Gee's Bend quilters. Their colors are amazing and I am in awe of their way of reusing blue jeans to make the subtlest tonal quilts.

- Abstract expressionist Robert Rauschenberg for his ordinary to extraordinary collages and "combines"

- Contemporary artist, author, friend, and former studio mate Sabrina Ward Harrison for the way she weaves photos, text, and paint

- Favorite Bay Area artist and surfer Thomas Campbell for his sewn patchwork paper

- Inspiring Brazilian artist Beatriz Milhazes. Check out her amazing full-scale color-filled collages with wild paints and patterns.

For more on these artists, see page 126.

I store my paper in drawers sorted by color.

Yellow and blue paper drawers

Green paper
drawer

Red paper
drawer

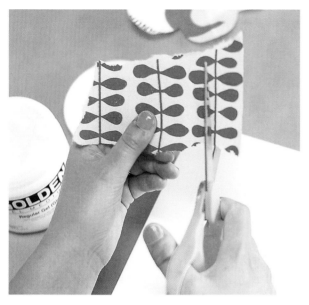

STEP 1

Just as you would if you were making a quilt, cut a square or rectangular shape and start your patchwork collage.

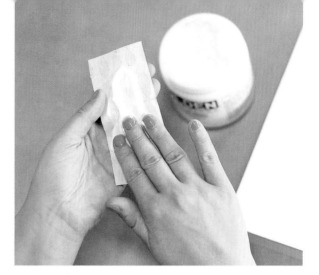

STEP 2

Using your fingers or a brush, coat both sides of the paper with the gel medium. I use golden medium body gloss; it is versatile, and you can mix it into paint as well as cover paintings with it.

STEP 3

Place the paper over your surface and make your own kind of quilt. You can overlap pieces; make them really large or tiny, uniform or wabi-sabi, matching or clashing. It's up to you.

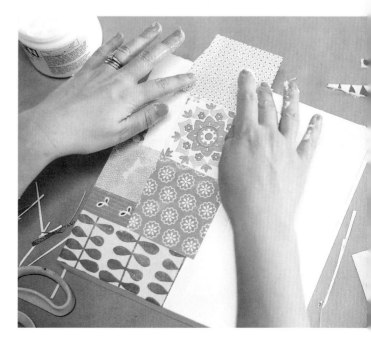

The idea of patchwork is to take all these different pieces of your life and make a story. The airmail letter holds memories. It has life. This painting is a combination of all my inspirations. You can be messy and imprecise, or very neat. Follow your impulse.

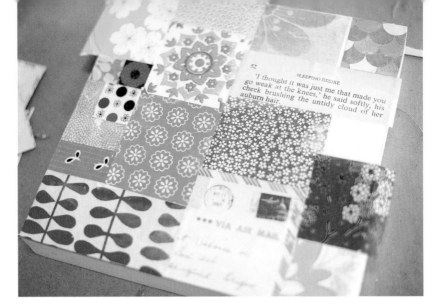

Instead of trying to fit each square to the canvas's edge, let it spill over freely and clean it up at the end.

STEP 4

To do the edging, turn the piece over and carefully run the craft knife along the edges to trim off any extending paper. This makes a very neat edge that brings contrast to the free-form collage.

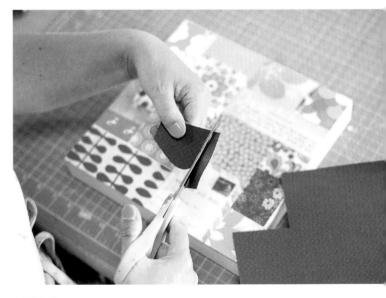

STEP 5

Next, cut collage shapes, such as a petal. Use the first petal as a template for the rest so that there is some consistency in size, without being exact. Play around with different compositions before adhering the petals.

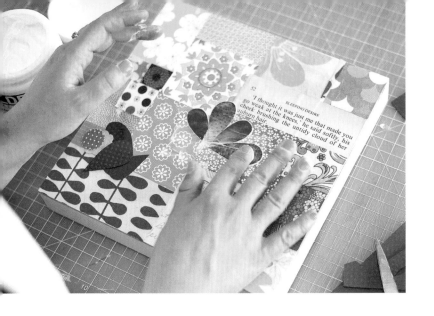

STEP 6

Use the gel medium to adhere the flower and its center to the canvas, and let it dry. (Reminder: You can speed up the drying process with a hair dryer or heat gun.)

Here is the finished flower with all of the petals and the central bloom. The graphic flower provides a nice contrast against the geometry of a patchwork collage background. I could continue to add flowers, leaves, and other images, but I also appreciate how the single flower centers the piece.

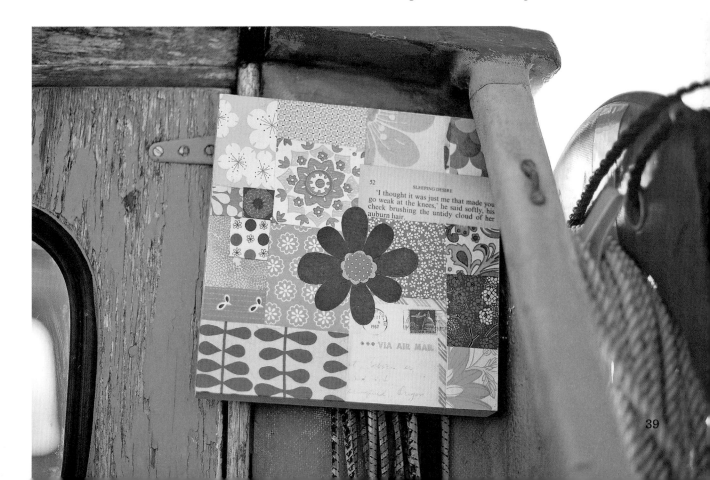

Location Inspiration:
Color Map Making of Your Neighborhood

There is no shortage of color in my neighborhood, the Mission District of San Francisco. When I'm looking for new color palettes and combinations, I put on my walking shoes and gather colors in my mind.

Notice the pattern, color, and palettes from your environment, and make a color map.

See the bursting pink bougainvillea overhead; the deep red of the interior of the bakery, with a stoic man painted with a side part; the curly turquoise of the wrought iron door; mangos and tomatoes at the fruit stand; green against pink and red paint; and the peachy-orange paint of the house mural below.

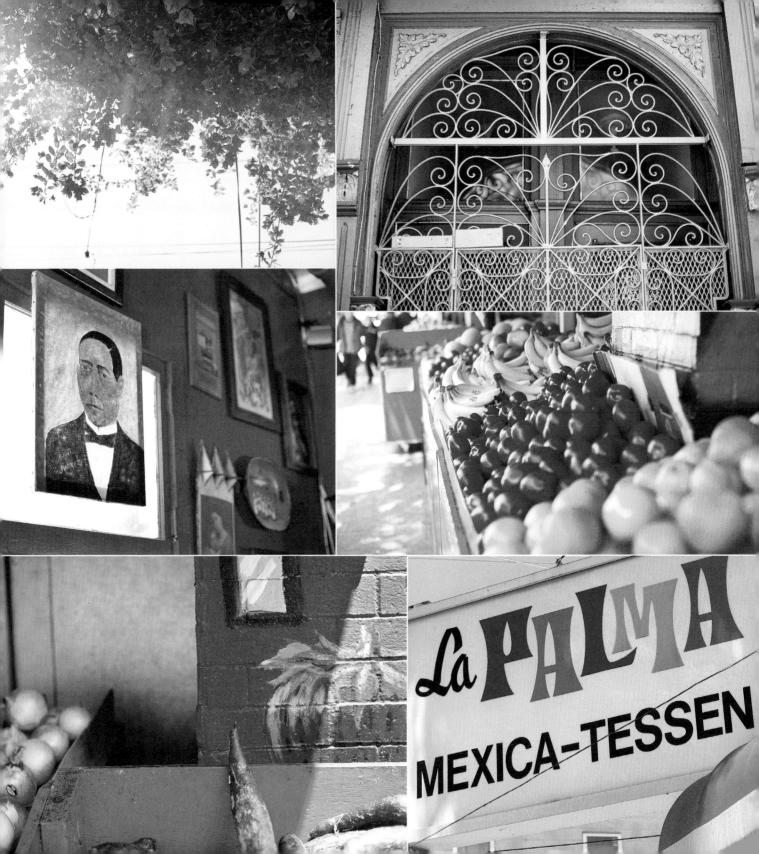

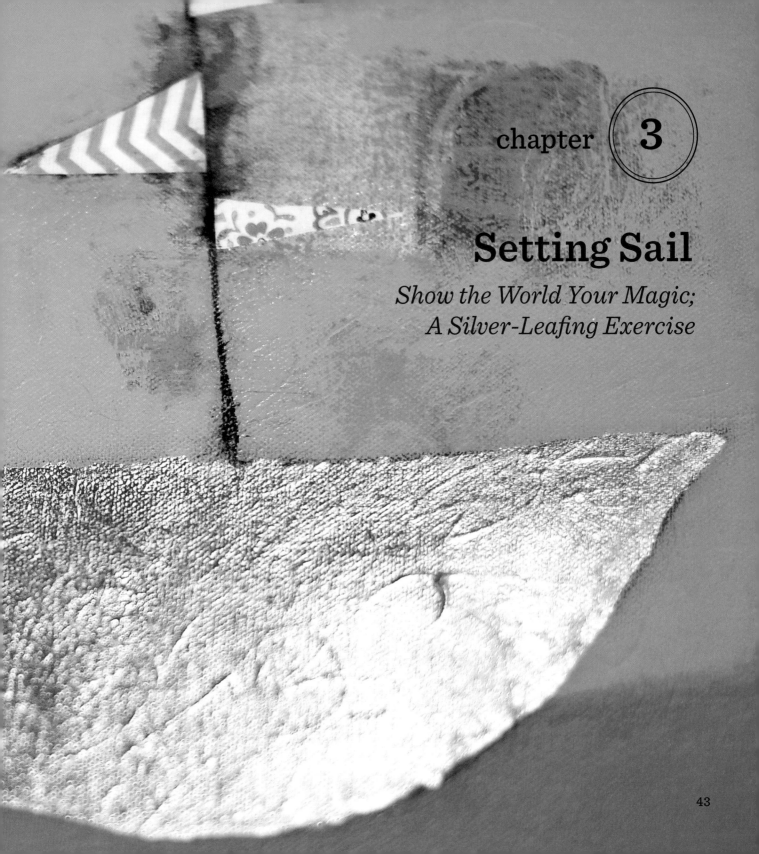

Setting Sail

Show the World Your Magic;
A Silver-Leafing Exercise

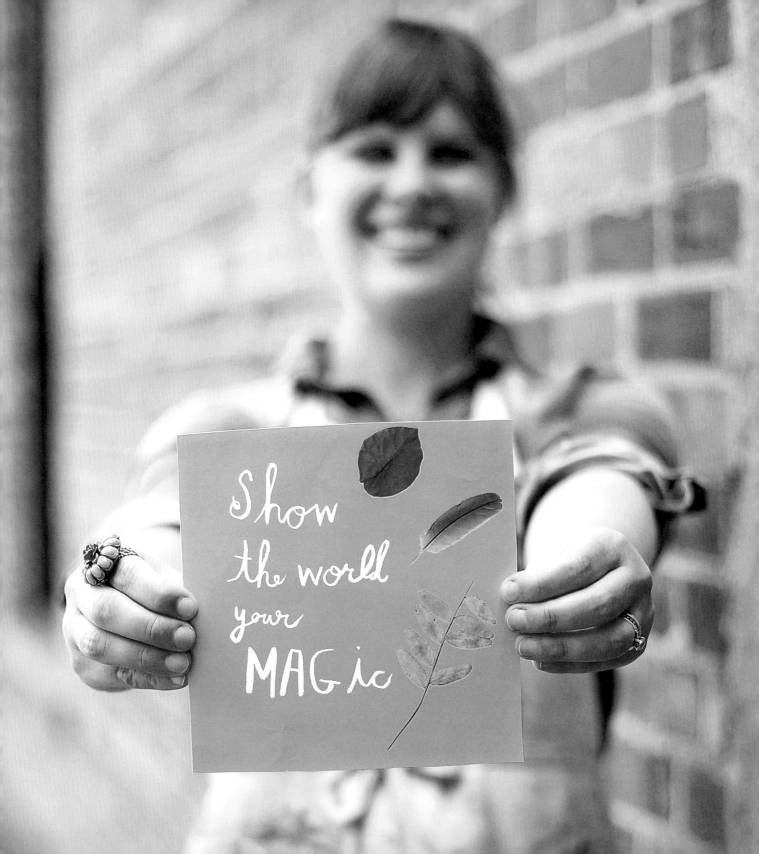

Show the World Your Magic

We all have a bit of magic in us. Magic that is completely ours, magic with our name on it, our own special brand of something wonderful. I want to encourage each of you to find whatever is within you and to trust it, to work toward it and to be faithful to it until it has landed solid within you, and you can recognize it on the page and see it for real.

So, how do we make room for this magic?

The past few years I've been meditating in my studio before I begin creating. It might sound lofty, but all I'm doing is simply sitting on a floor pillow for a few minutes and clearing my thoughts, repeating some form of this line: "Show the world your magic." I wrote it down and shared it with my blog readers.

Now I have it pinned to my inspiration wall. When I get stuck and overwhelmed by the oodles of art images and trends I see, I look up and say, "Mati, show the world … your magic." Show the world what no one else has that is uniquely *you*. This is not easy, mind you, but it helps to start from this place and eliminate some of the creative clutter and doubt.

I also try to remember the place that children occupy so easily, where they delightfully share their work with that thrill of "look what I've done!" That's such a free feeling. I try to find my way to that place in myself where I can blow away all inner and outer critics, the voices inside me that are afraid, that feel foolish, overly romantic, sentimental, childish, … the list goes on. (I have well-developed critics.) I try to stay true to myself and to the vision that wants to come through me and onto the page. This positive push works well in art making, but it also carries over to many other aspects of my life. I just feel better all around when I'm giving myself the freedom to simply make pictures without getting in my own way.

What do you want to share with the world that is your mark? What is at your core?

What makes your vision magic is that when you get out of the way and let this deeper vision flow, when you trust it and allow it, it can feel otherworldly. But if you don't allow it, as modern dancer Martha Graham says, "it will be lost".

> "There is vitality, a life force, an energy, a quickening, that is translated through you into action, and if you block it, it will never exist through any other medium and will be lost."

But it's not always easy. You might ask yourself, what if I don't have anything to share? What if I've lost my way? What if I don't exactly know yet? Yes, all of these fears will bubble up to the surface, and it is our job to trust our voice and move forward *in spite of them*!

I share this with you as an invitation, with the hope that it might help you out of a creative rut, and because it's confusing in the midst of trend forecasting and the immediacy of art and design blogs to not be insanely influenced. It's challenging to slow down, listen closely, and strive for original ideas and own *your magic*. I think it takes lots of practice and heaps of encouragement.

Sketching Exercise: Finding Inspiration at the Docks

There's no place more magical to me than the sea. For my "Treasure Seeking" silver-leaf ship series, I sat on the docks of the Berkeley Marina with my sketchbook in hand. Allow yourself to be open to inspiration. Let yourself be guided to your next step. Sketch what you see, and make as many mistakes as possible. Explore. Being outside and engaged with your environment is all about creative discovery and happy accidents and the unknown of what's in front of you! I was excited by the presence of an old pelican within arm's reach, and did my best to capture him in my sketchbook.

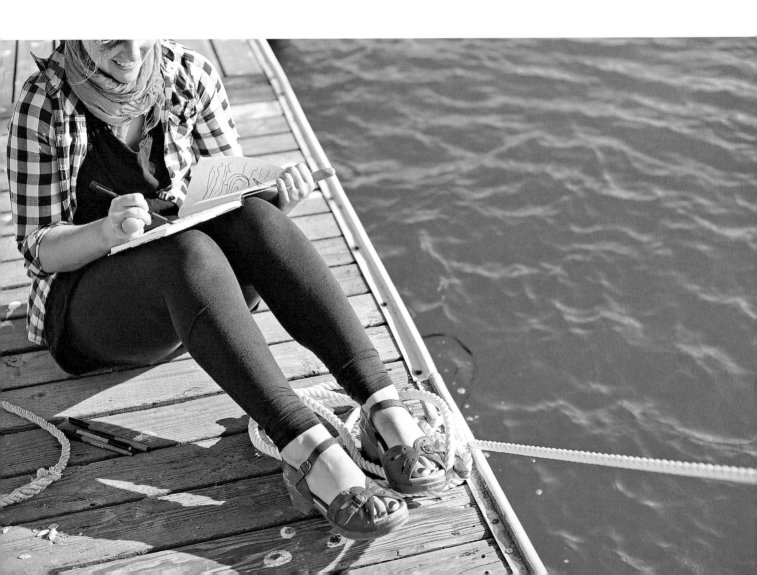

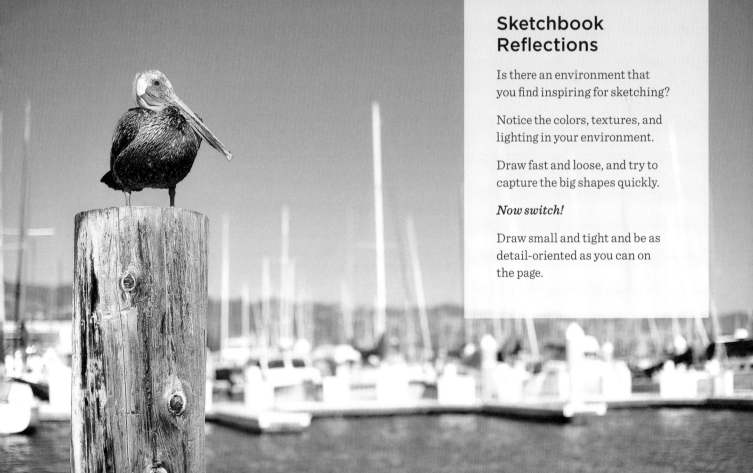

Sketchbook Reflections

Is there an environment that you find inspiring for sketching?

Notice the colors, textures, and lighting in your environment.

Draw fast and loose, and try to capture the big shapes quickly.

Now switch!

Draw small and tight and be as detail-oriented as you can on the page.

3 Background Painting, Sketching, and Silver Leaf

GOLD AND SILVER LEAF HAS A MAGIC QUALITY *that instantly elevates and transforms a painting—not only in terms of the glimmering end result, but also in terms of the process, from taking out the fragile shimmering piece of leaf to the way it breaks into tiny flecks of gold or silver.*

I started using gold and silver leaf after spending a month in Italy. I was inspired by how many of the Renaissance painters used gold leaf in their paintings of religious icons—in particular, painters Fra Angelico and Giotto. Another famous gold-leaf painter influenced by Italian paintings was Gustav Klimt. The technique is in evidence in his famous painting, *The Kiss.*

Materials

- acrylic paint
- collage paper
- silver- or gold-leaf package with adhesive
- gel medium

Tools

- brushes
- pencil for sketching (the Stabilo brand is my favorite)

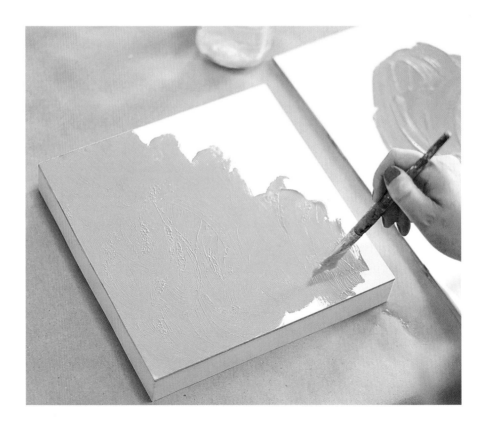

STEP 1

Mix some paint. Use turquoise paint and titanium white to soften the color. Paint the background color. Feel free to refer to chapter 1 where you painted multiple layers to create a rich background, or simply paint one flat color.

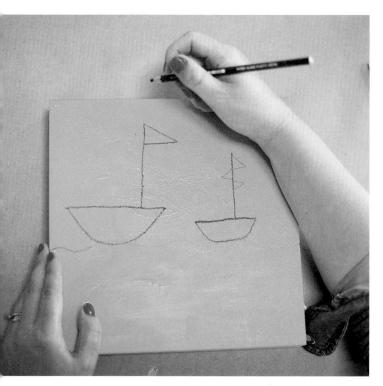

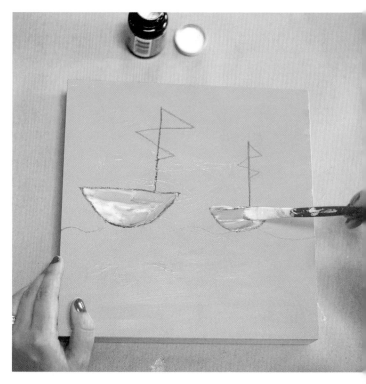

STEP 2

Draw your imagery. I simplified my boat sketches from earlier on the dock. Use a water-soluble graphite pencil such as a Stabilo pencil because it writes over most painting surfaces, and is very easy to wipe off with water and a towel if you change your mind and your sketch midway through.

STEP 3

Find the adhesive in the silver- or gold-leaf package. Using a brush, apply the adhesive to the areas of your sketch to where you want the silver leaf to be adhered. Do not apply the leaf, but let the adhesive dry for about an hour, at which point it will still be tacky but not wet.

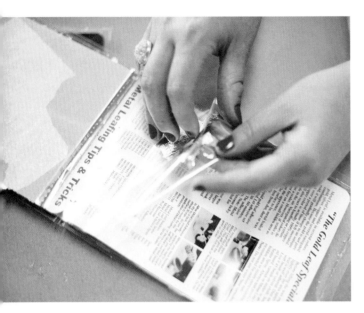

STEP 4

Take a single sheet of silver leaf carefully from its package. Refer to any special directions on your particular leaf package because they may vary.

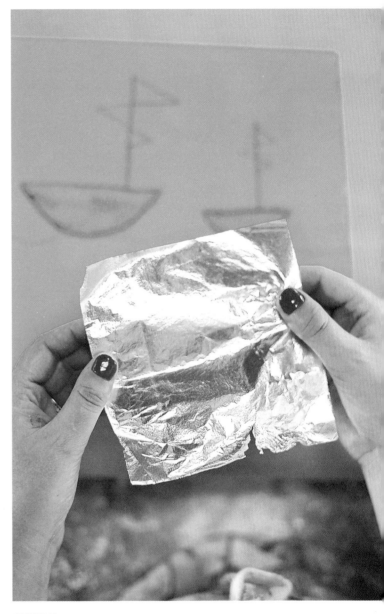

STEP 5

Place the entire sheet of silver leaf over the adhesive area of the canvas, and press.

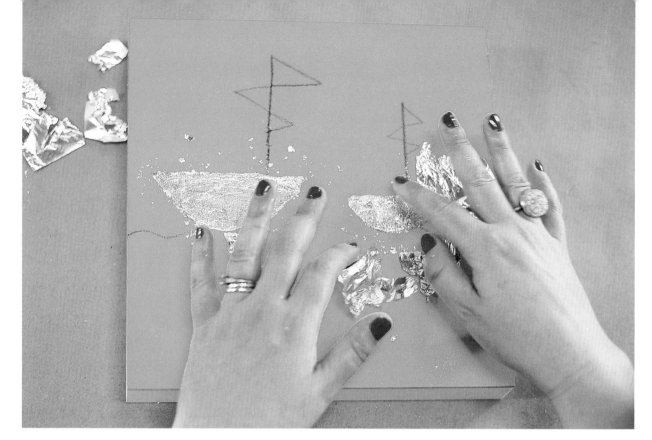

STEP 6

Continue to press the silver leaf onto the adhesive covering the imagery. You can press small bits or larger pieces into the adhesive and it will all become cohesive with layering. Break off the bits that don't adhere because they are outside the intended image.

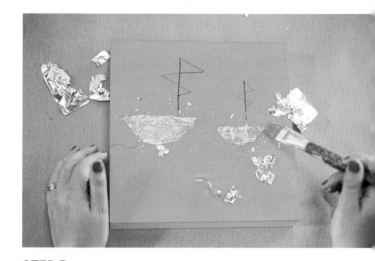

STEP 7

Using a stiff, dry paintbrush, brush the excess silver leaf from the canvas.

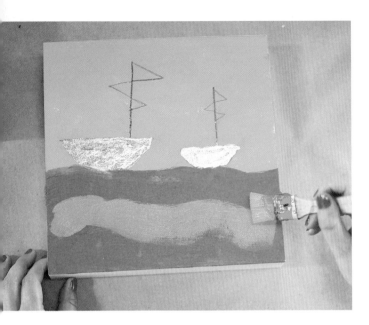

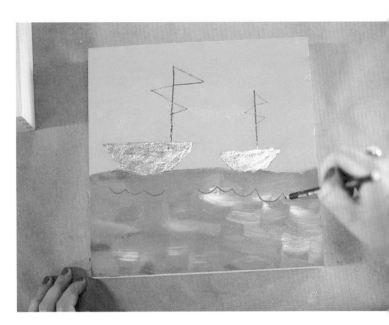

Defining Your Central Imagery

STEP 1

Next I want to show you how I build up a few layers of paint. I will create an ocean, but this method applies to any imagery. First, draw a horizon line with your pencil or paintbrush, and create the first layer of your ocean in paint. Use a darker color first and then go back in with a lighter color on top to create depth. I continue going back and forth between the darker and lighter shades with a little dry brushing as referenced in chapter 1, page 24.

STEP 2

While the paint is still wet, use your Stabilo pencil or another pointed tool to create shapes in the painting by making an impression. In my case, I'm making little waves.

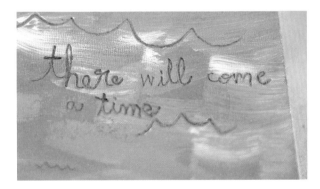

STEP 3

Using my pencil, I also took a line from music that was playing. I love to incorporate bits of eavesdropped music, poems, or conversations into my paintings, often spontaneously, while they are happening. Be experimental and daring!

STEP 4

As in the previous chapter, you can cut collage shapes to add interest and pattern to your painting. Here I have cut little triangles of paper for the sails and adhered them with gel medium.

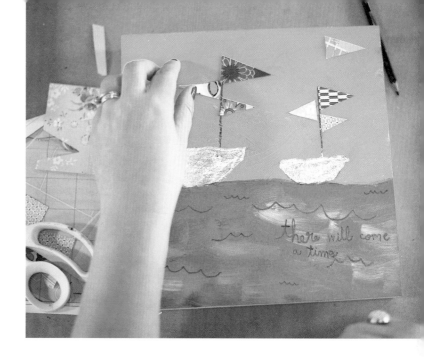

STEP 5

In the end, I felt like being bold and added a magenta scalloped embellishment on the top that I think helps tie the piece together with the colors of the collaged sails.

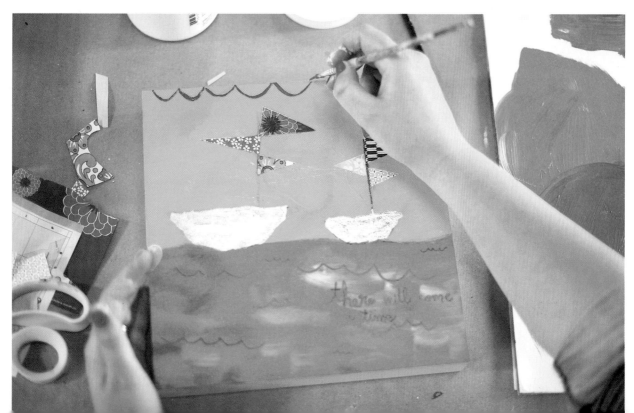

Location Inspiration: Berkeley Marina

Look at the sea for inspiration. Sometimes I write in my journal to get my creative juices going. Here I wrote out a scene to visualize for future paintings. Feel free to borrow mine as a prompt, or create your own.

Visualization

Pretend you're a feather-powered pirate at sea, soaking in the turquoise deep-sea water as far as the eye can see. You are surrounded by jewels, sea flowers, and bold, patterned silk scarves that are faded by sun and sea salt. Your ship is sturdy and you have a baby elephant on board that snuggles with you at night to keep you warm. You're playing your favorite sea tunes into the night. You feel alive, calm, and full of adventure. You raise your sails in the sun of day and stand at the helm of the ship. You sail up to tropical islands where you fill your treasure chest with more exquisite booty. You drink fresh mango juice as you sink into the warm sand, hear the waves lapping, feel the nourishing sun warm your skin, and take a nap.

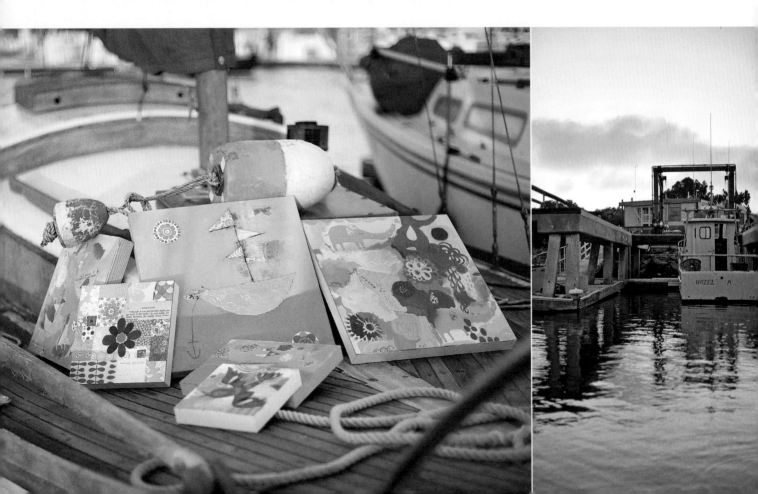

Staying the Course

*Follow Your Compass;
Exploring Doily Stencils*

Following Your Compass

How do we stay the course, keep ourselves current and inspired, and keep our self-critic out of the picture? Recently I realized that the word *compassion* includes the words *compass* and *passion* within it! I love the layers of truth within this. You use a compass to find your true north; your passion guides you there; and you need compassion for yourself and others along the way, especially in art making.

When I was in art school I had all these rules that I had constructed for myself. I have always been a people-pleaser and an *A* student, so I was making a checklist of how to get positive critiques. My rules in my senior-level painting class were: no illustrative art or cute, trendy, handwriting or Mission-style art (which is the neighborhood I live in, and where I began making art and what inevitably influences me); the list goes on. After one critique in particular,

I wrote on a piece of tape all the things the professor had said about my work and stuck the tape to my painting. Striving to get an *A*, I wanted to see how I could improve, but in doing so I visually digested the silliness and contradictions of what was deemed good or bad art, and though there really wasn't any rhyme or reason to it, I had make my own way.

On my last critique, I had the same senior-level professor say to me: "You don't really know what you're doing, do you?" This felt like the craziest affront. What then am I doing here?! Learning, that's what. Art is contradictory, because on the one hand you want to be a person who is sensitive and open to filtering your environment through art (like I am), and on the other hand you need to be completely outside of yourself and develop a thick skin. The biggest lesson that I learned from this, and what my teacher may have been nudging me toward, is this: Stop following the rules, and make your own!

After I left art school, I felt like so much of my creativity had been squashed, and it pushed me to finally rebel and make everything "wrong," which I see now is exactly how to make everything right: listening to my own voice and not the critiques of others. I look at the art I made in art school and see so much experimentation within my painting marks, but the actual paintings seem extremely ugly to me and paralyzed by "what not to do."

I think silk-screening hot pink lace elephants was one of my first rebellions after my art school days! I decided to embrace the thing that was the furthest from what I was being encouraged to do: doily elephants silk-screened in hot pink. It was my inner rebel saying "get lost, art school." I really identified

with these paintings for a while. They reminded me to play, and to embrace femininity, childhood, and girly colors.

I had another professor, Mark Eanes, who was more sensitive to my struggles, and who said to me, "The bad drawings have to be drawn and to the artist these become more important than those drawings later brought before the public." I love that statement. It reminds me that you will learn most from the work that you make for yourself when you are not thinking about impressing your audience.

4 Doily Stencils

ABOUT FIVE YEARS AGO, *when I was on a limited art supply budget, I was shopping at thrift and hardware stores for my materials. I discovered how beautiful and unexpected the shapes of doilies become when you spray paint over them. Soon I became obsessed with experimenting, layering one pattern over another, and seeing the psychedelic patterns they created.*

Materials

- spray paint
- canvas
- doilies or other stencil-like shapes

Setting Up

In a ventilated space, preferably outside, set up a drop cloth and a large area for spray painting. I set up outside my studio on a little grassy knoll.

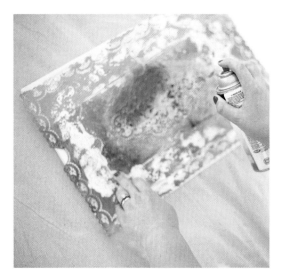

STEP 1

In a thrift store, I found a well-loved old plastic place-mat in a lace pattern and chose hot pink spray paint. You can use any interesting shape and spray paint over it! Be bold and experiment!

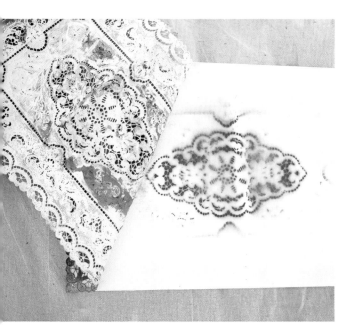

STEP 2

Discover the beauty that is revealed underneath as you lift the doily or, in this case, placemat.

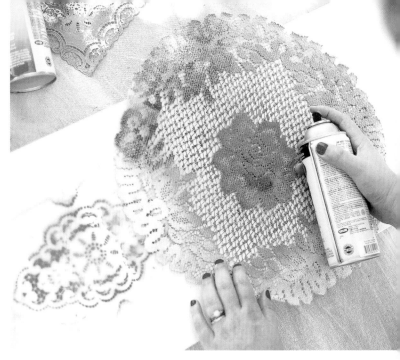

STEP 3

Choose another doily. Mine has a pretty rose shape on it that I'm drawn to, and I chose a purple paint. Repeat the spray painting.

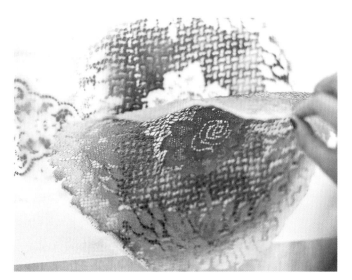

STEP 4

Lift up the doily again to see the surprise underneath!

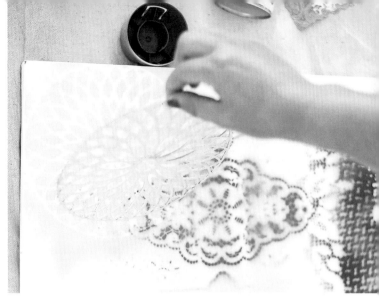

STEP 6

Reveal the third shape by carefully lifting the doily off the canvas.

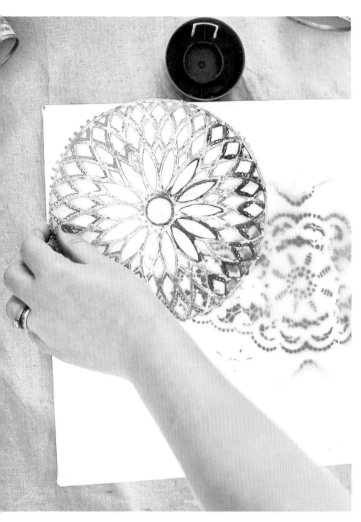

STEP 5

This unusual vent with a great symmetrical pattern was found on the ground. For this one, I chose a pale-pink spray paint to use with it. When layering your patterns, notice where you are placing them in relation to others.

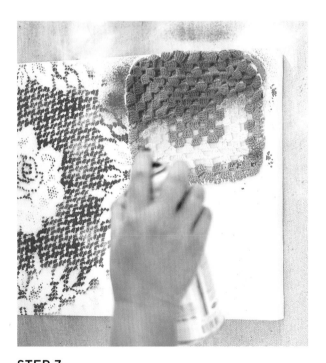

STEP 7

Use another doily and continue to experiment by spray painting over it too.

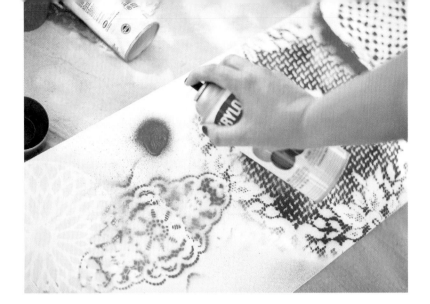

STEP 8

You can use spray paint alone in the painting to add a burst of color.

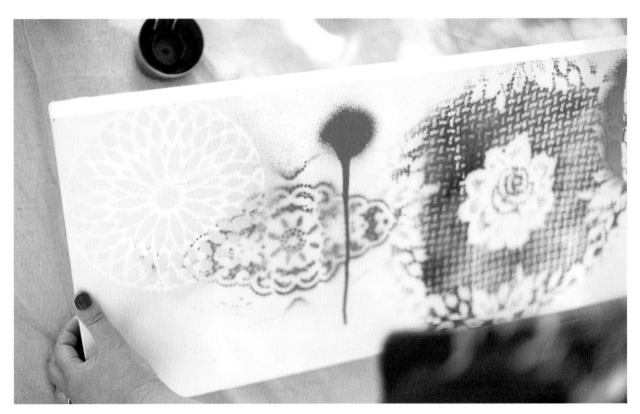

STEP 9

While the spray paint is still wet, tilt the canvas on its side and watch how the paint drips.

You can stop here, or you can fill in the white areas with washy layers of paint.

Location Inspiration:
Scavenging for Treasures

find the best inspiration for my paintings at thrift stores and flea markets. Silk scarves and embroidered Mexican dresses are my staples for finding an inspirational dose of color and pattern.

I love secondhand treasures of any variety. Lately I've been collecting small sewn dolls, model boats, and blue bottles, but the thrill of seeking is that a new treasure could be uncovered at any moment.

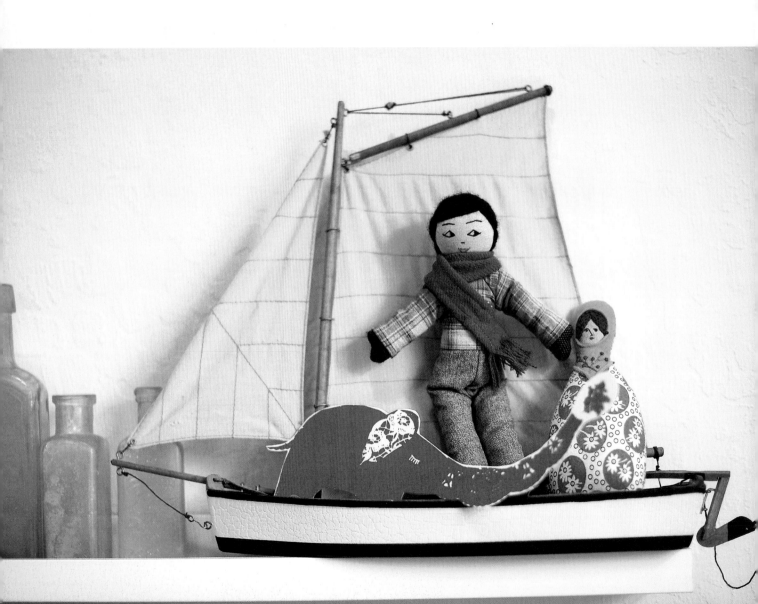

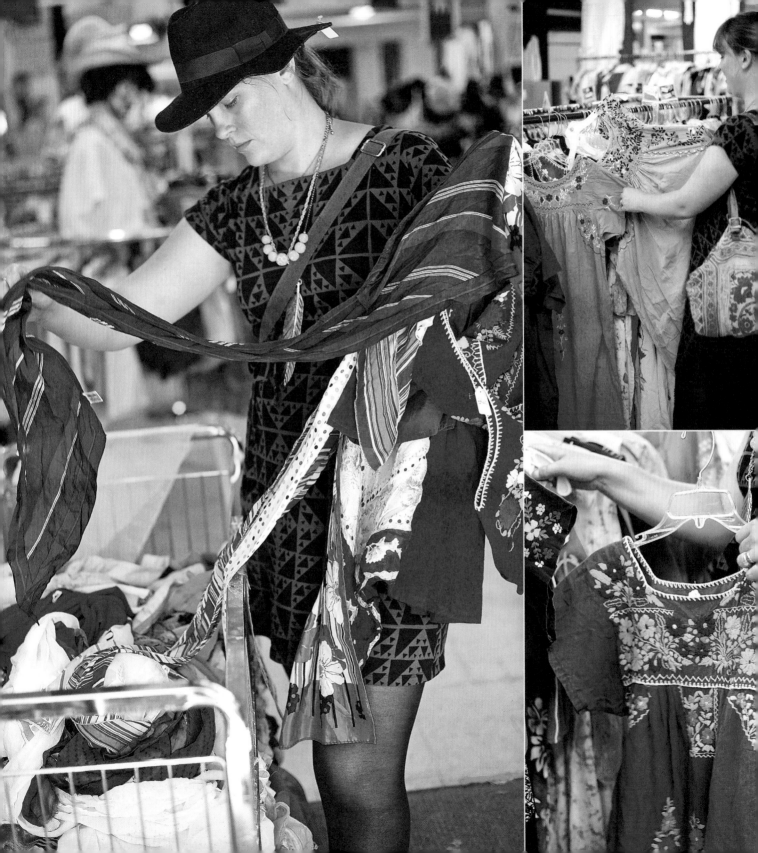

Anchoring

Finding Your Voice;
Transferring Your Sketches to Paint

Finding Your Voice

In this chapter we will explore the ideas of finding your voice and bringing authenticity to your art. This is what some people call your style! Your voice is what makes your work distinctly yours, and something that no one else can emulate exactly. Your voice is a mixture of all the sparkliness and grit that tells your story. You have your own unique voice and perspective whether you've identified it or not—from the books you've read to the people whom you've loved, all of your peculiar delights and hard times lived. This grab bag of goodies melds into your essence, and is something that you can bring on and off the canvas. It's the way you see things, it's the words that come out of your mouth, it's your penchant for certain colors or the way things fit together in your vision. As visual artists, we all gravitate toward certain color combinations, subject matter, and compositions, and we need not second-guess that and wonder if it's good enough. We must trust and use our voices, or else we will not be making our own art.

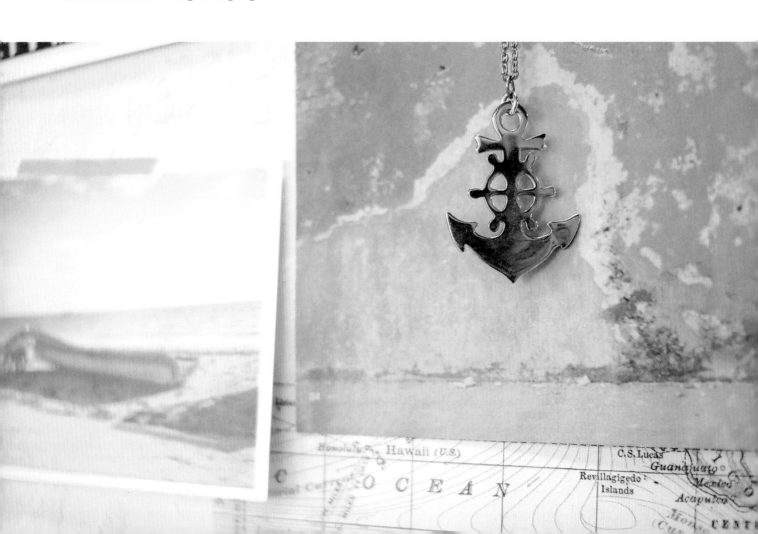

More than four years ago, I was invited to an art retreat on the Oregon coast with a group of powerful women and talented artists. During the retreat, my wise, Superhero friend Andrea Scher led our group through a core values exercise where I discovered that I was a Treasure Seeking Pirate. I wasn't really sure what that meant or how to live that out at the time, but as I continue to paint, it's coming into focus.

She asked the deceptively simple question:

Whom do you admire? Please answer this for yourself.

We wrote down the names of these people and she asked us to talk about what qualities these people had that we admired. Most of them had qualities that we ourselves possessed on some level. I partnered with my hilarious and soulful friend Jen Gray who said she admired Maude from *Harold and Maude*. I was surprised how well Maude fits my image of Jen. I wrote about my art heroes, including Maira Kalman, who joins my camp of treasure seeking with this quote from her book *The Principles of Uncertainty*:

"My dream is to walk around the world. A smallish backpack, all essentials neatly in place. A camera. A notebook. A traveling paint set. A hat. Good shoes. A nice pleated (green?) skirt for the occasional seaside hotel afternoon dance." (See Resources, page 126, for more on this artist.)

We circled the qualities that overlapped between these people. The qualities that came through with the people that I admire were that they are all passionate, smart, curious, quirky, and marching to the beat of their own drum. Throughout their lives, they are seeking treasures by noticing the ordinary in life and transforming it into their unique bounty.

With art-making, we make treasured discoveries on a daily basis. My mode is to look for these treasures wherever I am and to be grateful for these little nuggets. A small stroll can be amped up by

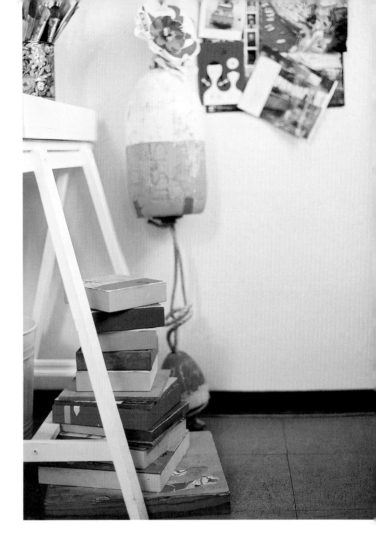

intentionally seeking inspiration and appreciating how it crosses your path.

I came away from the retreat with my Treasure-Seeking mantra and felt like I had returned to myself; my eight-year-old self. The last day we were there I took a little walk to the tide pools. I climbed up on the edge of the coast, barefoot among the barnacles, peered at a starfish, and sang to a sea urchin. I thought of how much love I have for this crazy, wild, world and how I am just where I need to be. I returned to myself and also discovered loving pirate-seeking treasures and trusting in the happy ending.

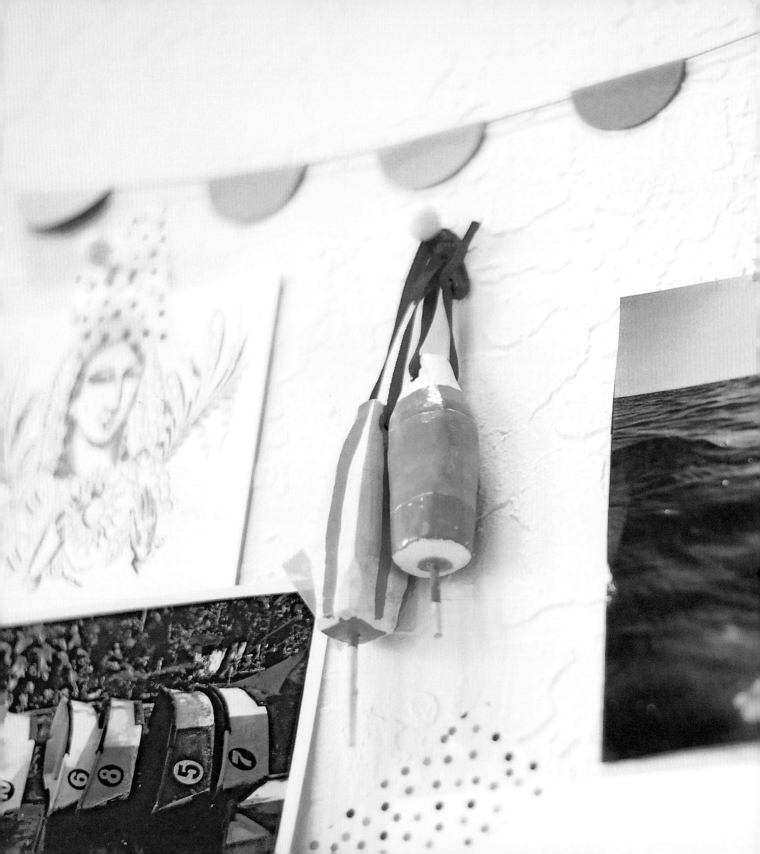

Authenticity: Inspiration Inventory

- *Who are the people that you admire? List five.*

- *What traits do they possess?*

- *What did you most enjoy drawing when you were eight years old?*

- *What were some of your favorite books when you were a child?*

To jog your memory, I'll share a few of my favorite books:

Mine were *Corduroy* by Don Freeman, *A Little Princess* and *The Secret Garden,* both by Frances Hodgson Burnett, *Little House on the Prairie* by Laura Ingalls Wilder, and *Anne of Green Gables* by Lucy Maud Montgomery.

- *What are your favorite movies today?*

- *Is there a recurring theme in the stories you are drawn to? The imagery?*

You can see that I'm fond of all things nautical, especially buoys and anchors.

- *How might you paint these symbols that you collect—whether in the form of stories or tangible objects?*

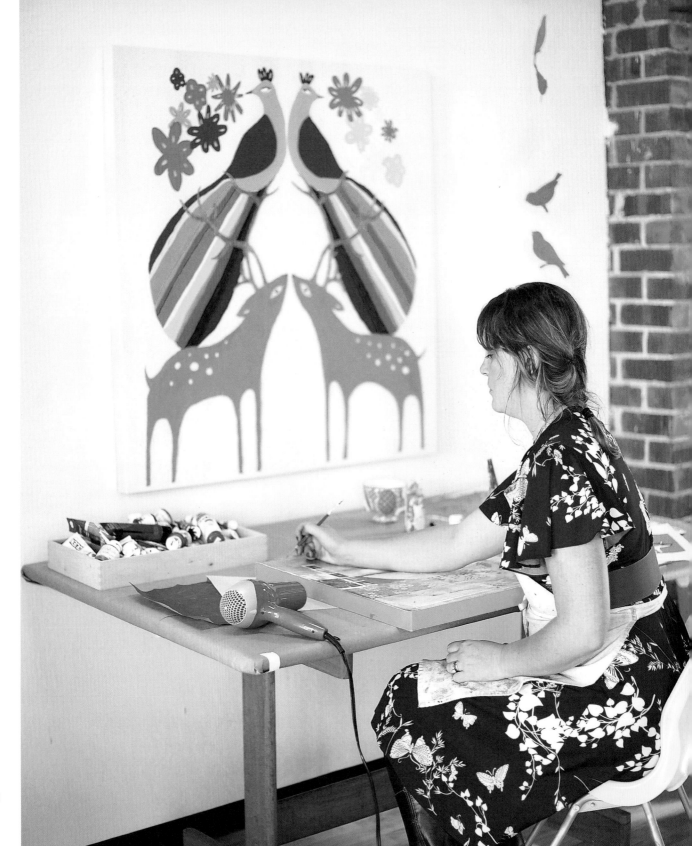

transfer exercise

5 Sketching and Layering Paint

IN THIS EXERCISE WE'RE GOING TO EXPLORE *the process of planning a drawing through sketching, and using some tricks such as tracing and transfer paper. Haven't you always wondered how you get the sketches from your notebook onto your canvas?*

Pictured opposite, above my worktable in my studio, is a symmetrical painting of deer and peacocks. I was originally inspired to do a series of these symmetrical paintings after I found a great book focused on American folk art in the 1800s in an antiques store in Vermont. This book was such a boon because it showed naively drawn animals, many of them made from cut paper or, some-times, watercolor, and they unfolded like symmetrical snowflakes. I had no idea at the time I came across this book that it would inspire a new series. This series led to illustration work, including a T-shirt line produced by the outdoors apparel store Patagonia. The point is, you never know where the thread of an idea or pulling over at a little thrift store may lead you!

Materials

- transfer paper
- acrylic paint
- base to paint on
- tracing paper

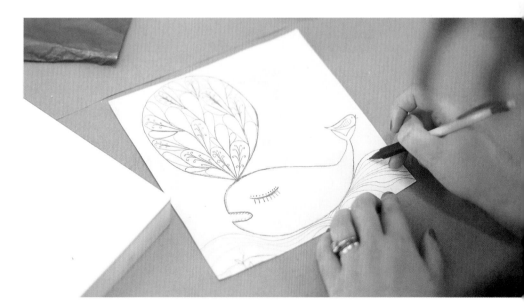

STEP 1
Draw your imagery, either from life or from your head. Start with a simple sketch.

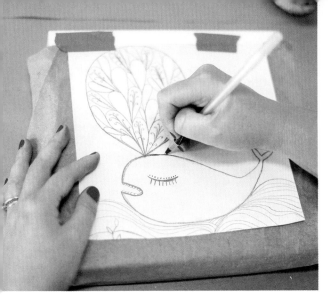

STEP 2

Lay a piece of transfer paper (the same as your substrate) graphite-side-down over the top of your sketch. Position and tape your sketch on top where you want the imagery to be. This application works best on a hard surface such as wood panel or paper on top of a hard desk. (Canvas is possible, but your transfer may not be as successful.)

TIP: *You can also use a #2 pencil or graphite instead of transfer paper. You will want to evenly cover the entire backside of your sketch completely with pencil.*

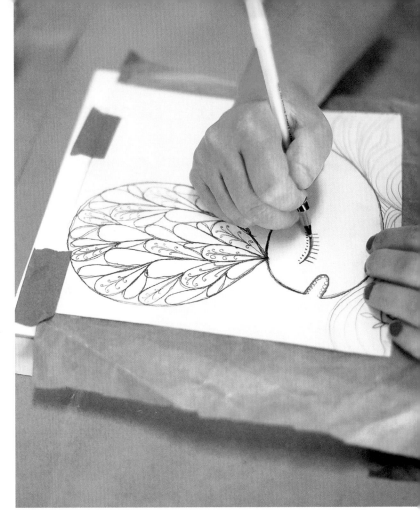

STEP 3

Use a regular ballpoint pen to transfer your sketch, preferably in a different color than your original sketch. Pencils are sometimes too soft, and markers will not work at all because you need the force of a hard tip to make the transfer. Push down with your ballpoint pen to trace over the lines of your sketch.

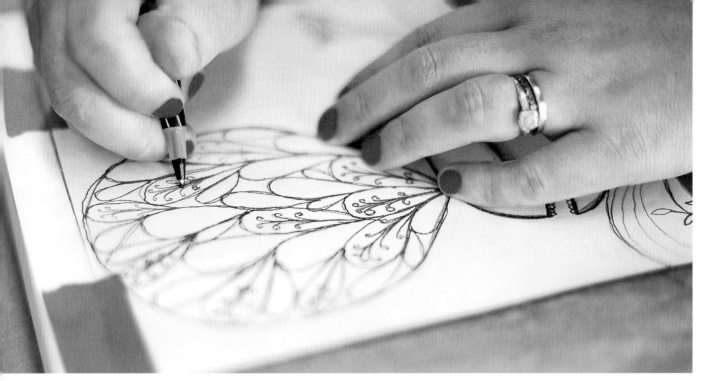

STEP 4

Continue filling in all of the details you want captured on your painting.

STEP 5

Carefully remove the transfer paper and lift up the taped-on paper as shown in the picture to check your transfer. Be sure to leave the tape intact so that it will be in the same position if you want to go back over some lines.

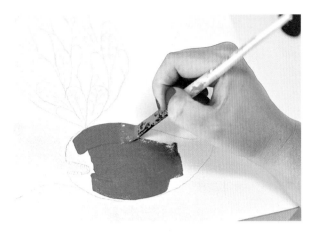

Painting a Flat and Graphic Painting

STEP 1

Mix your desired paint color and paint in your transferred imagery. I start with the figure first.

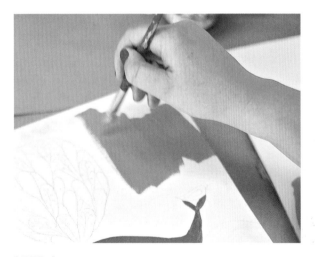

STEP 2

Paint your background color, making sure to cover all the open areas. Paint with flat, even strokes. At this stage you can finesse the shape of the imagery with the painted edge of the background paint. This is more obvious in the next step as you see the whale come more into focus.

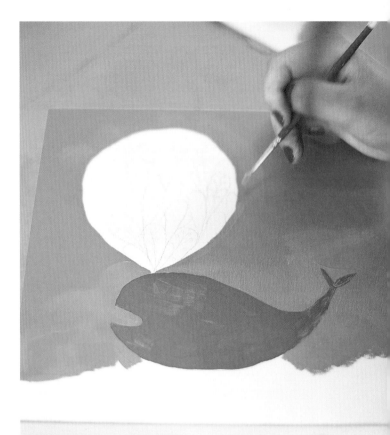

STEP 3

Paint the background right to the edge of the imagery. Beginner painters often leave a gap between the imagery and the background, and it actually is preferable to paint directly next to the image so that it is a connected piece and gives the sense of an actual foreground and background.

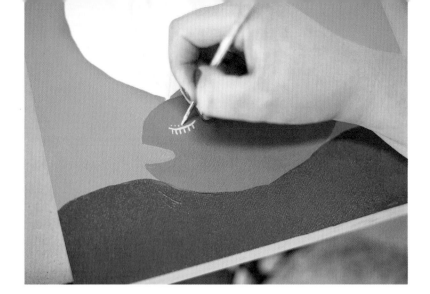

STEP 4

Start adding the details on your imagery to give it greater interest and scale.

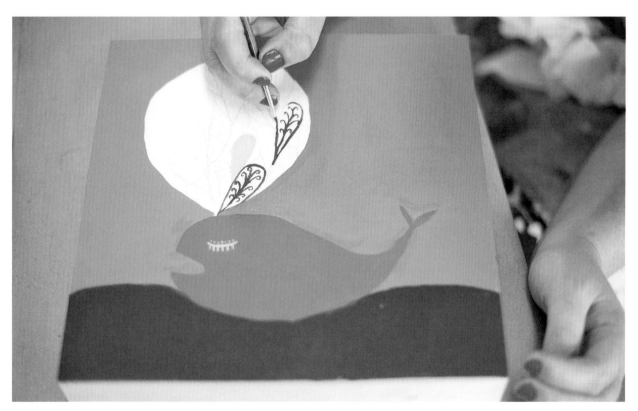

STEP 5

Continue painting in the details with a fine-tipped brush.

Location Inspiration: Rare Device

One of my favorite stores in San Francisco is the boutique, Rare Device owned by Gizelle and Phurba Gyalzen. I feel lucky to have a local boutique that is supportive of my art. It is important for me to have a connection to my community and have my art integrated into the world around me. Last summer I had a show there with a fantastic artist from Maine named Jennifer Judd-McGee in which we created paintings inspired by vintage board games. We collected a bunch of vintage board games and created a window installation. I sell my colorful elephant prints there and created a large removable mural for the children's section. See Resources, page 126, for more on artist Jennifer Judd-McGee and Rare Device.

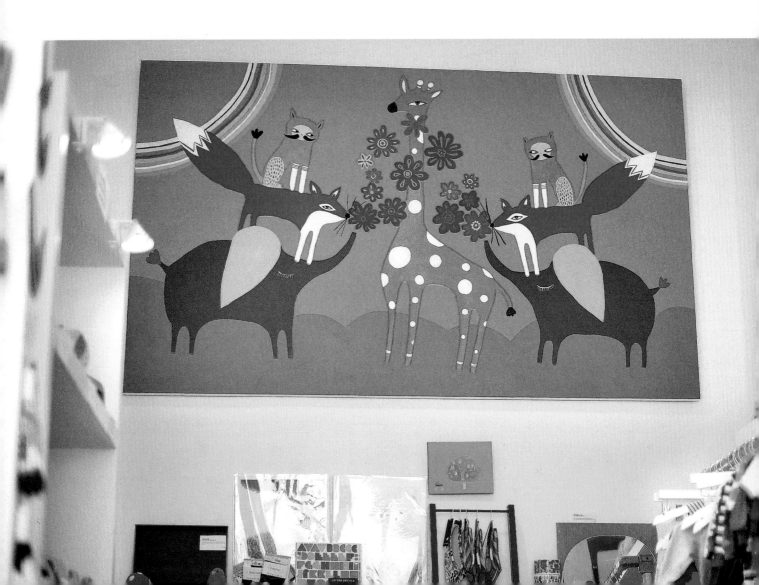

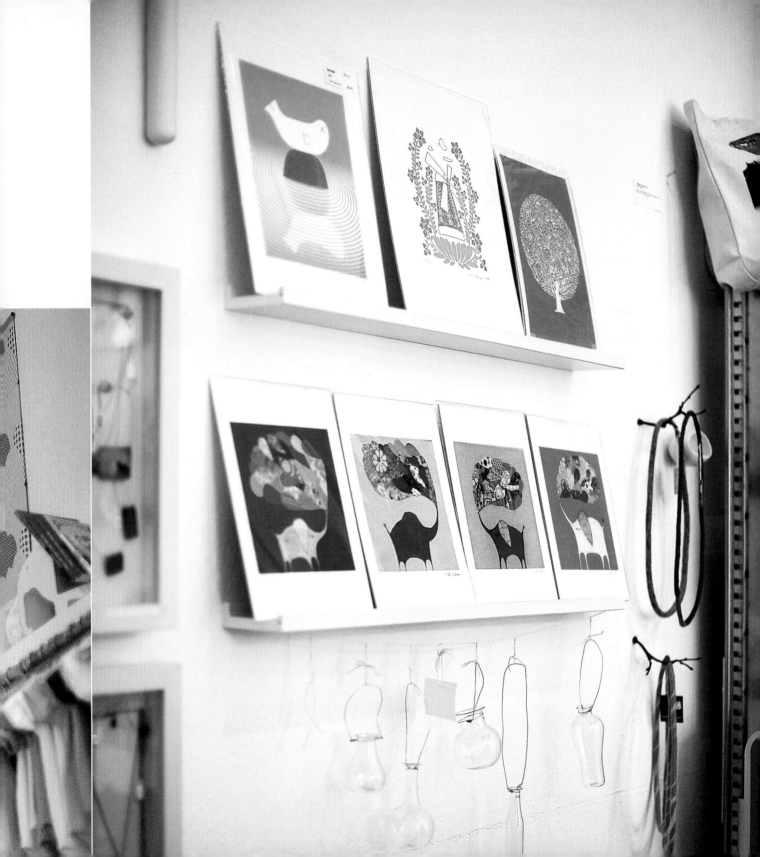

Finding Flow

Filling Up the Well;
Collaborating with Another Artist

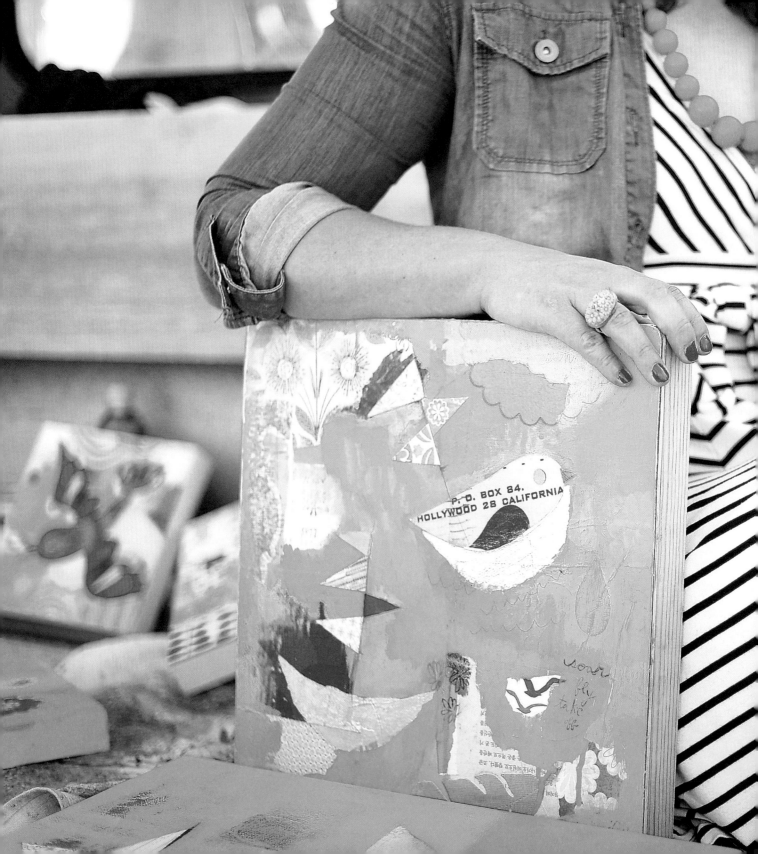

Filling Up the Well

The topic of finding flow reminds me of one summer I spent in Nova Scotia when I was about ten years old and I learned how to find well water. Sadly, the house of our old fisherman neighbor, Hartley, had burned down earlier that year, and he was in the process of looking for a water source for his newly built, little red home. Holding out a Y-shaped metal prong called a divining rod, I was led to the corner of the yard with a gravitational pull that felt like magic. Shortly after that, Hartley dug for water in that spot and had a well built that was his primary water source for the rest of his years. Finding flow in our work can sometimes feel as elusive as divining for water with a metal rod, but you know it when you are in the current. You are completely present and engaged with what is in front of you, exhilarated by this feeling and knowing where you are heading as if led by a divining rod. Usually flow hits me when my body is moving and my head, heart, and hands are all aligned in creating.

Flow goes hand and hand with your voice. You need to begin to trust it and do what feels natural to you, even seemingly obvious and easy to you. Often we think good work has to be hard. What if flow is simply surrendering to what is natural to you?

I had a conversation with my brilliant, smart, illustration agent and mentor, Lilla Rogers, last year when I was in an art-making funk, asking her: "How can I step things up?" She said that I was doing everything right (thank you, Lilla) and that I should paint things that are fun and easy for me— smooshy colors, lines, and what comes naturally to me, not to others. That, she said, is where your authentic voice lives.

It was a very big "aha" moment. Paint what is easy to me? Wait, I don't have to work at it? Make it perfect? Make it like math? I can keep it mysterious and evocative and fun? I can play with color and paint and go off on little painting explorations? *Yes*!

Sketchbook Reflection: Tapping the Flow

- *Write about what makes you feel adventurous.*

Notice beauty in the details.
Red dahlias in an eggshell blue vase, Early Girl sweet tomatoes from the farmer's market, lemons from our backyard in a Mason jar; I'm wearing a big wooden ring, striped shirt, and braided fabric necklace made by my mom. All feels complete and treasured.

- *Write about a memory from when you felt alive.*

For me, working at Prescott Park in New Hampshire one summer when I was in my twenties made me feel alive and strong. My job description at the park included deadheading flowers; creating flower sculptures; hanging above the ocean's surface while repairing the side of the wooden dock; draining and filling the lucky penny fountain while standing in it; and mowing the lawn while driving a big tractor, wearing a bright yellow rain slicker when it happened to be raining.

- *How do you bring adventure into your daily life?*

I hike up my favorite stomping ground, Bernal Hill, and notice the flowers and secret staircases and slides!

Daring Prompts in Paint

- Use color that you wouldn't normally use.

- Close your eyes, pick a color, and use that color no matter what.

- Paint with your less dominant hand.

- Collaborate with another artist on a painting, or two! Keep trading back and forth.

- Flip your painting upside down.

- Let a child draw on it.

- Try different substances in your kitchen.

- Use anything but a paintbrush!

- Experiment with dipping paint and making marks with: lids, silverware, Q-tips, keys, yogurt tops, toilet paper rolls, paint caps, bubble wrap, wheels, tissue paper, fingernails, Legos, cars, sticks, credit cards, fingers, pen caps, and so on!

- Go into recycling bin and find materials.

- Use fruit, potatoes—anything you have around you for mark making.

- Sew into your work.

- Play with scale. Make tiny shapes next to GIANT ones.

- Do a short walk around block and find something to collage into your painting: a gum wrapper, feather, or leaf. Get outside!

- Embrace repetition.

- Cut up your painting and paste it back together.

- Mix a coarse material into your paint, such as sand.

- Incorporate memories through photos.

- Spill paint.

- Dab paint.

- Wet the canvas first and then paint wet on wet.

- White out a big section of your painting.

- Cover a big piece of your painting with a bold color.

Collaborate and Mentor

I have collaborated with several artists in the past few years, and I love doing so. My friend, Lisa Congdon, and I painted some collaborative paintings for an art show we had together—you will meet her and see her studio at the end of this chapter. We each started independently on our own paintings and then switched and worked on each other's paintings, coming together for our show. This is one way to collaborate that works well, especially if you live far away from someone—I happened to be in Maine while working toward this show and Lisa was in California.

I've also collaborated many times with my artist friend, Kelly Rae Roberts on paintings. We painted side-by-side just as if we were children playing together; riffing off of each other in response to our paintings. What was great about this experience was that she hadn't painted in a while after her move to Seattle, and had hardly unpacked her art supplies. Through painting together, we were able to make it fun and easy for her to begin again. Try this with a friend if you feel blocked. It's a great way to learn new painting techniques too, because you are literally painting next to each other.

In the same capacity, Kelly said to me once that I was one of her mentors, and while I was flattered, I didn't really get it. Recently, I realized what she meant, because she is a mentor of mine as well. She has helped me navigate through many creative business decisions and difficult spots. She has encouraged me to aim higher and believe in what is possible if you envision it. It was a shift in my thinking about who a mentor can be. I thought mentors had to be wise teachers that were older than me. It was an epiphany that a mentor can also be a peer. They can mirror your creative dreams and possibilities as you work side by side. We all want mentors. Sometimes those relationships don't happen in the traditional way, and I'm grateful for that.

Try to collaborate with your friends and art mentors! In this chapter I'm going to show you how artist Hugh D'Andrade and I work together.

6 Making a Painting with Another Artist

FIND AN ARTIST YOU WANT TO COLLABORATE WITH. *It could be a friend, an artist with more or less experience than you, or even your child! Each time you collaborate with someone you will learn something new, and the sum of your parts will create something more incredible than what either of you may have come up with on your own.*

Materials

- acrylic paint
- Acrylic Flow Improver or other paint extender
- pencil
- 3M rule paper for sketching
- a partner

STEP 1

Have one person start with a pencil sketch. Think about the composition and allow room for your collaborative partner to sketch too. Hugh D'Andrade likes to draw big, simple shapes. He chose to make the line of the water about two-thirds of the way up the canvas. Hugh likes to vary the scale of his composition to keep it interesting.

STEP 2

The second person adds to the sketch. In this case I add an elephant in the boat.

STEP 3

Working together you can go twice as fast! While Hugh was sketching, I made a layered background.

TIP: *Acrylic Flow Improver dilutes acrylic in a way that is similar to how water dilutes watercolor paint. It enables you to have a flat, wet, and smooth line. If Hugh had just used water, the acrylic paint would be gloppy, and he wouldn't have as much control with it.*

STEP 4

I hand the canvas off to Hugh. He uses a flat brush and dilutes the paint with Acrylic Flow Improver to make the lines nice and smooth.

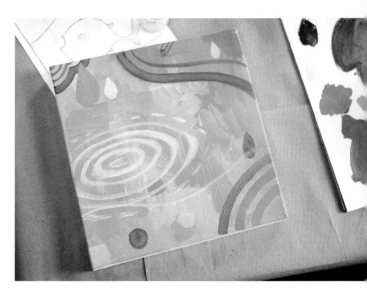

Hugh paints stripes and concentric circles that will become the ripples in the water.

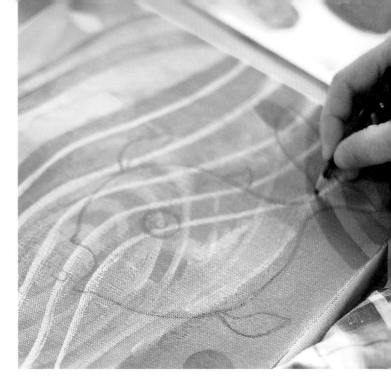

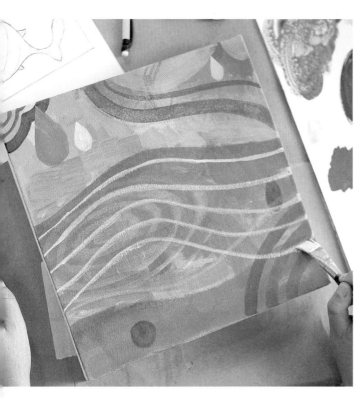

STEP 5
Hugh chose darker blue (using Flow Improver) to create the shape that will become the ocean. I'm adding white lines to the ocean.

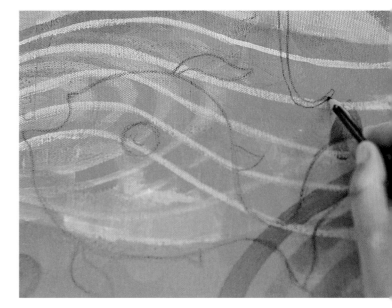

STEP 6
Since the sketch is so simple in this painting and Hugh is great at freehand sketching, he draws directly on the canvas with a navy Stabilo pencil.

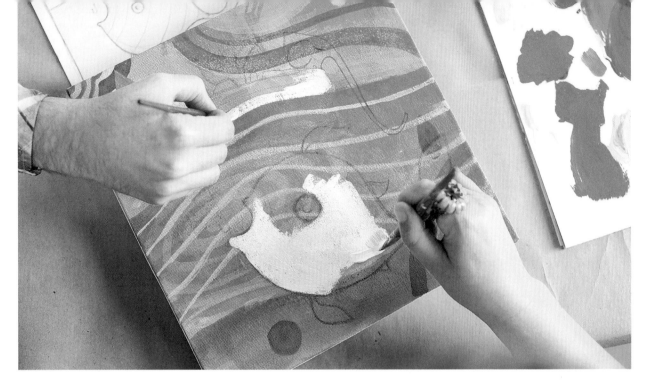

STEP 7

Together we paint white over the areas that will become the figures. We do this so that when we paint the layer of colors they will be their true colors—just like putting a base of primer down on a wall. If we didn't put this layer of white down, there's a chance that the colors would be muddy and fade into the background, and it would take further layers to build up this level of paint opacity.

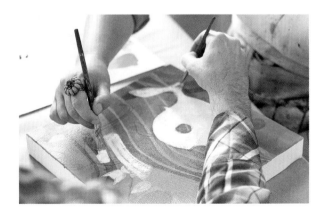

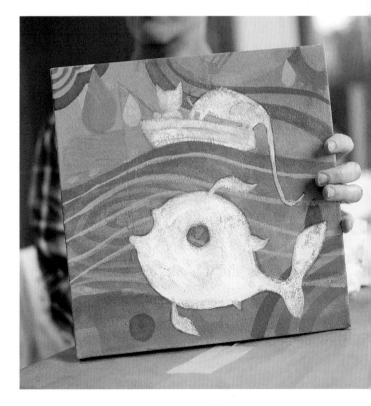

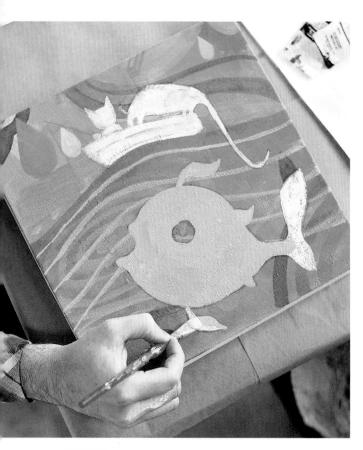

STEP 9

Again we choose contrasting colors with the blue, such as the lime for the elephant and the orange for the boat.

STEP 8

We are choosing colors that will contrast brightly with the blue. Here we choose a pink that doesn't have a lot of blue in it, so it really contrasts—it's not a purplish pink.

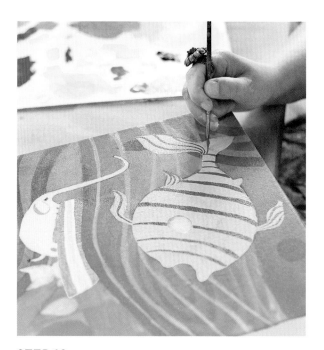

STEP 10

We decide to play up the repetition of the stripes by painting stripes in the opposite direction on the fish.

STEP 11

For the cat's face, Hugh used a fine-detail brush and more Acrylic Flow Improver to make precise lines. He did this in several layers to get it just right.

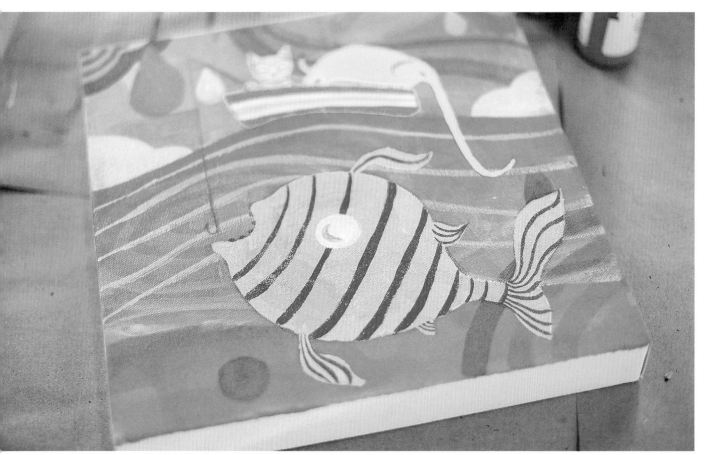

Location Inspiration:
Lisa Congdon's Art Studio

Lisa and I have collaborated on many things: paintings, shows, and an online painting class. Much like Kelly Rae Roberts, I think of Lisa as an artistic mentor and true inspiration because of the way she lives her life on and off the canvas. Her way with color and design is awe inspiring, as is her personal drive, compassion for others, and ability to be true to herself. It's important to seek out as many artistic and uplifting friends as possible, whether through the Internet, books, or from classes. It can be a lonely path if you don't connect with other creatives who share your vision of the world. See Resources, page 126, for more on this artist.

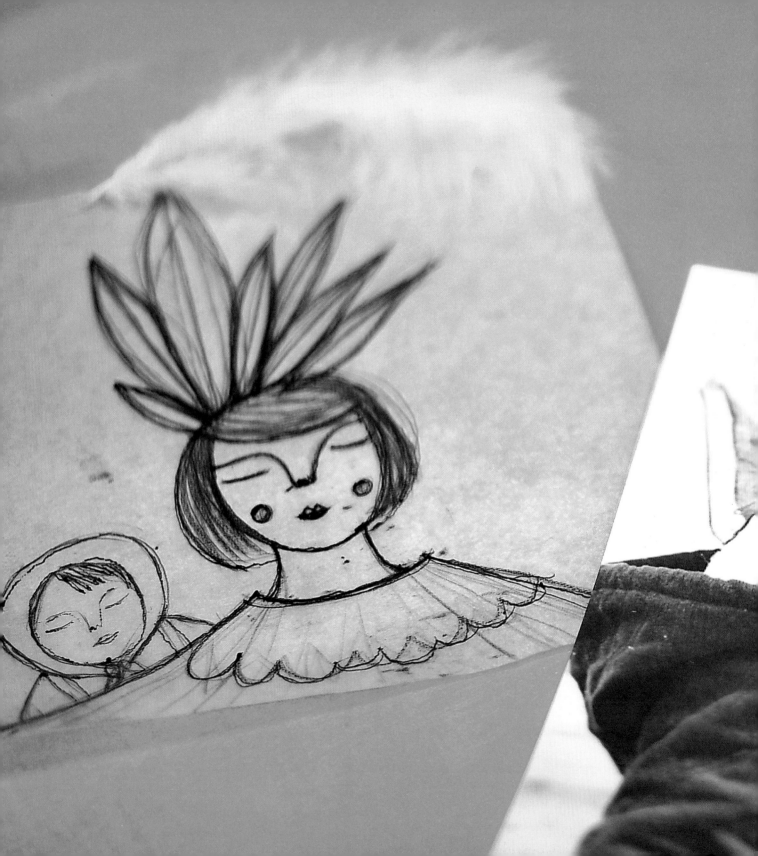

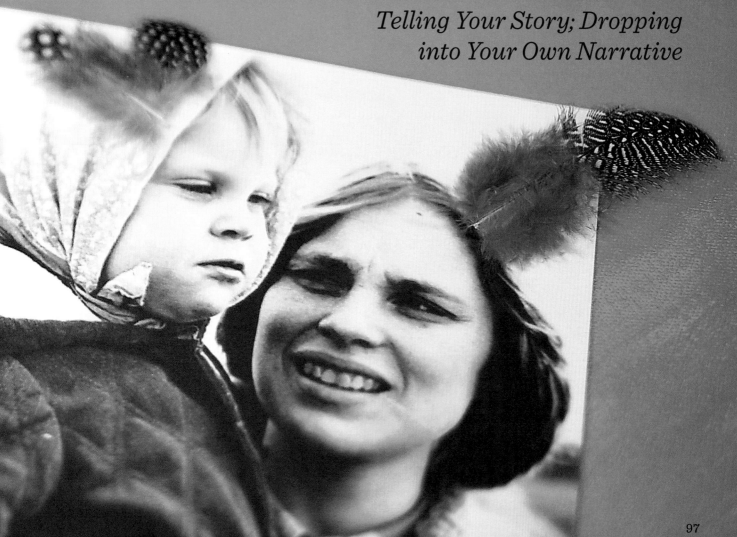

Treasures

*Telling Your Story; Dropping
into Your Own Narrative*

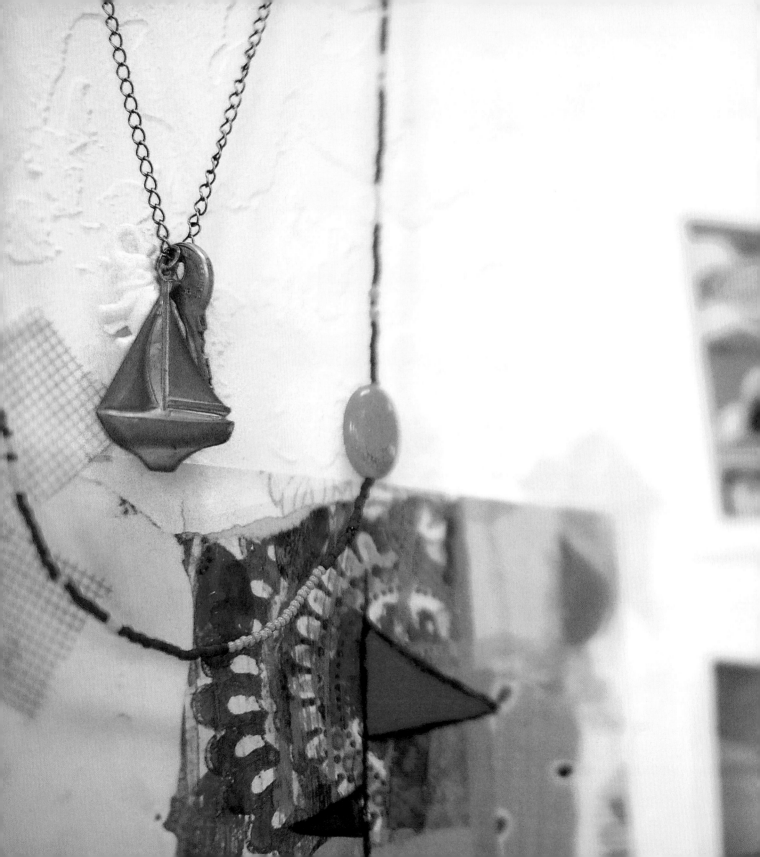

Telling Your Story

How do you pull together all the painting techniques you have learned and then take it to another level where you're not only playing with color, composition, and materials, but also telling stories? If you are not comfortable with paint already, just know that with practice and time you will get to a place where you are confident enough to tell the stories you are destined to share through your art. There is a deep power in telling stories with art. We all have stories to tell. These are your treasures to uncover! But don't wait until your confidence catches up with you.

One of my first art classes in San Francisco was a children's book illustration class. I was unhappy working as an assistant at a law firm and decided to take a night art class to shake it up. I ended up writing a story about a girl and her Chihuahua who ate their way through the Mission . . . and the dog kept getting fatter and fatter. This was essentially a story of me fetching lunch for the lawyers—but based on the resident office dog named Chiquita at the small law firm in the Mission. Through this process of creating a children's book, my lunch break was transformed as I started noticing the details of my neighborhood. The muralists who were painting the buildings in view out my windows became characters in my story. I invented adventures for "Rosa" who makes *pupusas* (a traditional Salvadorian dish made of thick, handmade corn tortillas usually filled with cheese) and her journey emigrating from El Salvador. The common sight of men selling ice cream out of carts in my neighborhood became a central plot line. By writing and illustrating my story, I became more alive and engaged with my surroundings. Instead of bemoaning the annoying details of a day at the law

firm, my imagination took flight and I became acutely aware of all the inspiration in my midst.

This is the power of making art—it allows you to open up to the stories that are all around you, to notice your experience in the world, and see it as valuable and story-worthy. When you are present, engaged, and alive you can fully document your time here, and leave messages for future generations. So, what is your journey like? What stories are alive in your world?

Making art that's inspired from the world we live in is a little like putting a message in a bottle and sending it out to sea—it's a way to share our experiences. This is particularly fitting for me because my dad was an artist who died when I was a baby and left behind mountains of woodcuts, sculptures, and sketches that I later uncovered bit by bit. I literally learned who he was through his art. But this is also true throughout the ages. That is why a good book lasts and why we have art museums. Make your mark! Start today! What are you waiting for?

7 Dropping into Your Own Narrative

Materials

- acrylic paint
- photo reference
- collage: paper, fabric, feathers
- gel medium

Tools

- pencil for sketching
- transfer paper
- pen for transferring

INFUSE YOUR MEMORIES AND STORIES *into your paintings. In my Feather Power series, my story is about honoring powerful women. The photograph from which I derived the inspiration shows my mom as a strong single mom with me as a baby wearing my folk-patterned kerchief.*

STEP 2
The transfer paper was not as successful as I would have liked, so I went over the lines and darkened them so that they would be more legible for painting.

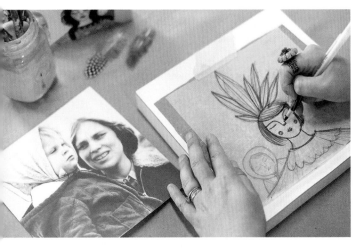

STEP 1
I sketched a drawing based on a photograph of my mom and me from the time of our cross-country road trip. I simplified the shapes to make the figure more universal, and therefore relatable, and changed the positioning of me as a baby onto her back. Using transfer paper, I transferred the sketch of these figures onto canvas.

ARTIST ADMIRATION

Some of my favorite contemporary narrative artists include friend and former teacher Jason Jägel, Swedish artist Camilla Engman, and contemporary artist Amy Cutler.

STEP 3

The photo is black and white, but the feeling evoked for me is of a time rich with deep, twilightlike, calm colors. I chose a purplish blue shade for the background.

STEP 4

I paint the first layer of skin and hair.

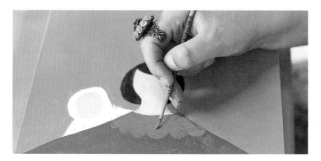

STEP 5

Using my ring that I'm wearing as inspiration, I decide to incorporate the bright green color and scalloped shape into the poncho.

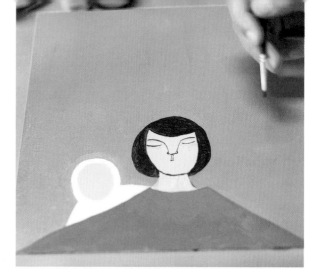

STEP 6

I paint over the face with another layer of muted skin color, allowing the highlights to pop up from the previous color underneath the eyes. Choosing a small tipped brush, I work into the face with detailed lines indicating the brow, nose, eyelids, and indentation between the nose and lips and a neckline. I leave the neck itself painted with only the first layer of paint.

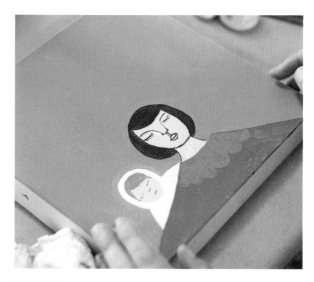

STEP 7

Continuing to paint in the facial details, I paint the lips, the eyelashes, and the baby's features.

STEP 9

Testing out the scarf for the baby, I realize I need to paint the garment underneath first so that it appears like it's layered under the scarf fabric. Also at this point, I note another similar '70s pattern scored from a piece of vintage wallpaper and set it aside, pondering how to incorporate it into the piece.

STEP 8

I take some time to consider what color I should paint the scarf. I decide to look in my drawers and happen upon an actual piece of fabric from my mom's collection of fabric scraps from the 1970s. Perfect! I cut the handkerchief shape just like I'm playing with paper dolls from my past, and try it out.

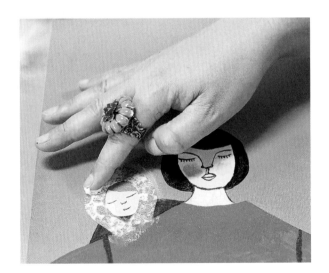

STEP 10

Using gel medium, I cover both sides of the fabric and adhere it to the painting.

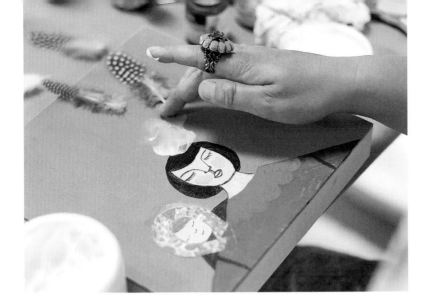

STEP 11

In the past with this series, I've painted the feathers, but I recently collected a bunch of beautiful real feathers that I decide I want to collage onto the painting directly using gel medium.

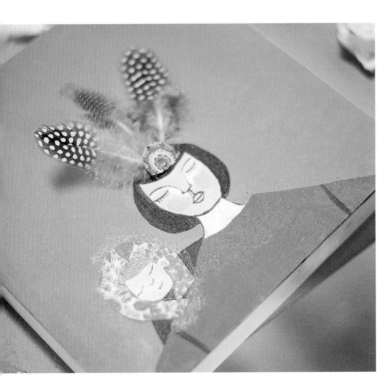

STEP 12

The feathers are looking a bit clumped and matted down with the gel medium, so a solution dawns on me to cover this area with a small piece of ornamentation from the wallpaper piece set aside! Beautiful!

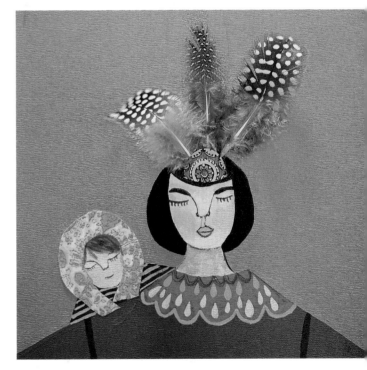

STEP 13

I continue to add more ornamentation in paint on the poncho and the baby's shirt. I also go over the faces with some fine-tuning, painting on eyebrows and rosy cheeks to give it added sweetness and beauty.

Location Inspiration: My Home

Surround your home with art. It is important to me to live a life surrounded by beauty. We live in a time when everything is designed beautifully; from our sheets to our soap, we are surrounded by elegantly designed items. Just as with paintings, beauty does not need to be expensive or trendy. Look within to discover what is uniquely compelling to you and let this inspiration overflow into your art!

The little blue rocking chair with artist Nate Williams' pillow on top

The painting which I created in a class led by artist Flora Bowley

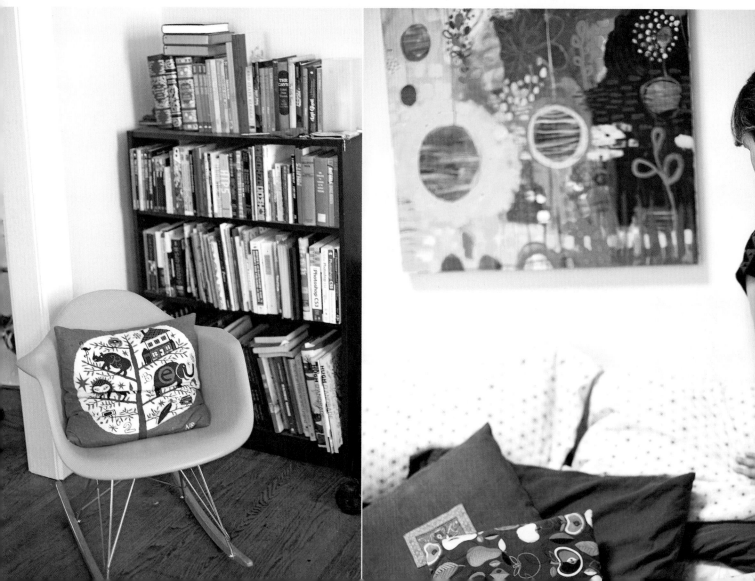

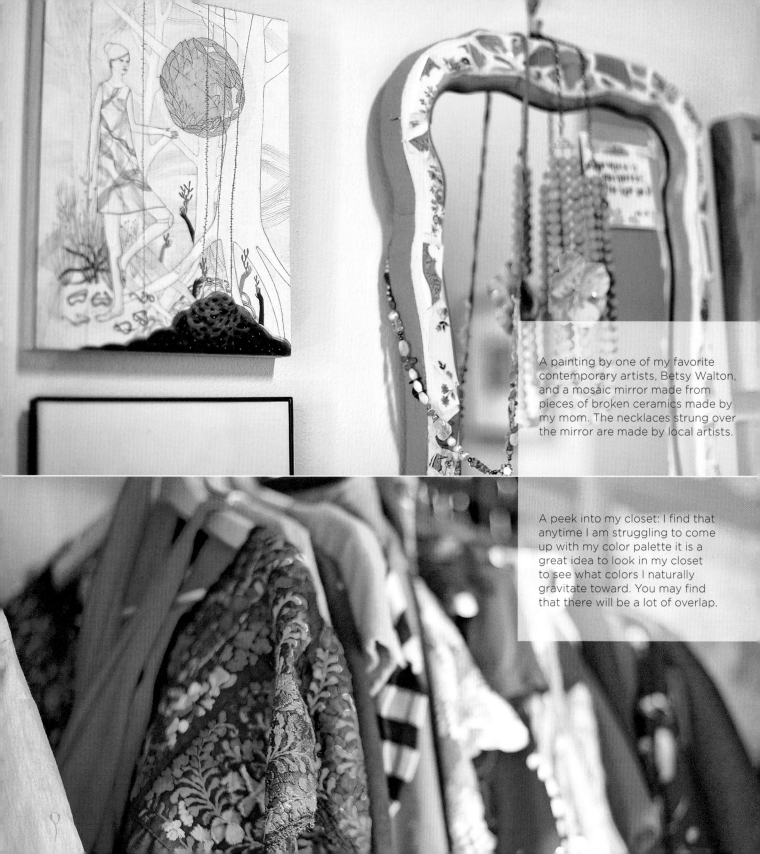

A painting by one of my favorite contemporary artists, Betsy Walton, and a mosaic mirror made from pieces of broken ceramics made by my mom. The necklaces strung over the mirror are made by local artists.

A peek into my closet: I find that anytime I am struggling to come up with my color palette it is a great idea to look in my closet to see what colors I naturally gravitate toward. You may find that there will be a lot of overlap.

Tying it All Together

*Layering Your Painting
With All the Techniques*

Layering Exercise: Collage Layer

This chapter shows how all of the techniques learned in this book cannot only be used separately, as in the previous chapters, but integrated together into one painting. When I began the process of painting this canvas, there was no ultimate plan. The intention was to just use all these different modes of working, one layer after another. Starting with the painted, layered background that we created in chapter 1, I spread a layer of gel medium down to begin the collage layer. With the previous patchwork collage exercise in chapter 2, we worked with scissors to cut the paper. This time I'm going for a much more free-form style and I rip the paper with my hands and feel my way around for the best composition.

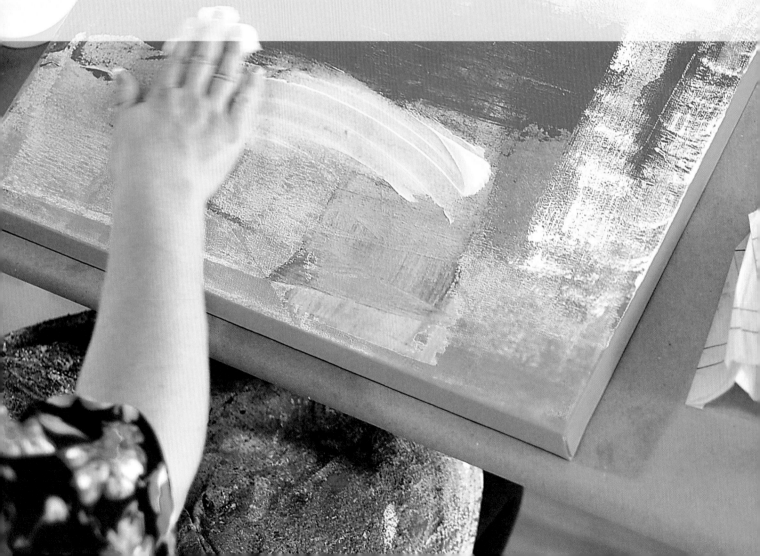

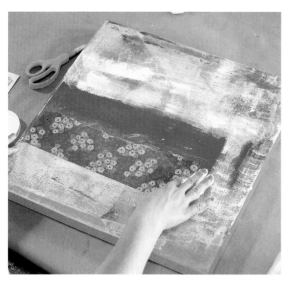

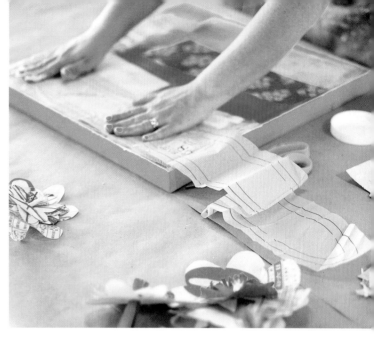

I love this piece of beautiful paper, so I'm going to use a large strip and adhere it to the canvas.

Then I'm going to add this vintage sewing pattern over the painting for a semitranslucent effect.

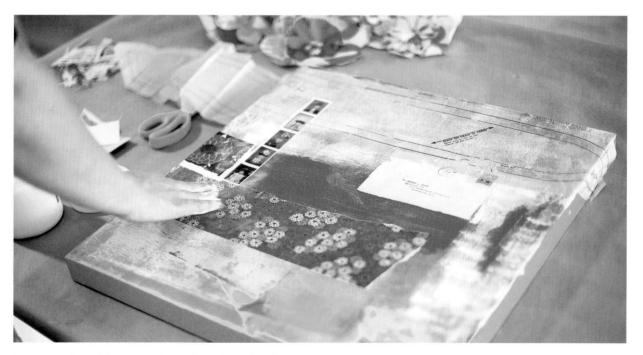

I continue by adding an old envelope from the flea market, an old photo strip, and a favorite flower card.

Enhancing Your Silver-Leaf Skills

Here you see how you can incorporate silver leaf with the original painting that we just collaged onto, or on top of any painting that is already in progress and has a built-up background. Using the same silver leaf technique from chapter 3, I'm going to make the silver-leafed boat the central image in the composition.

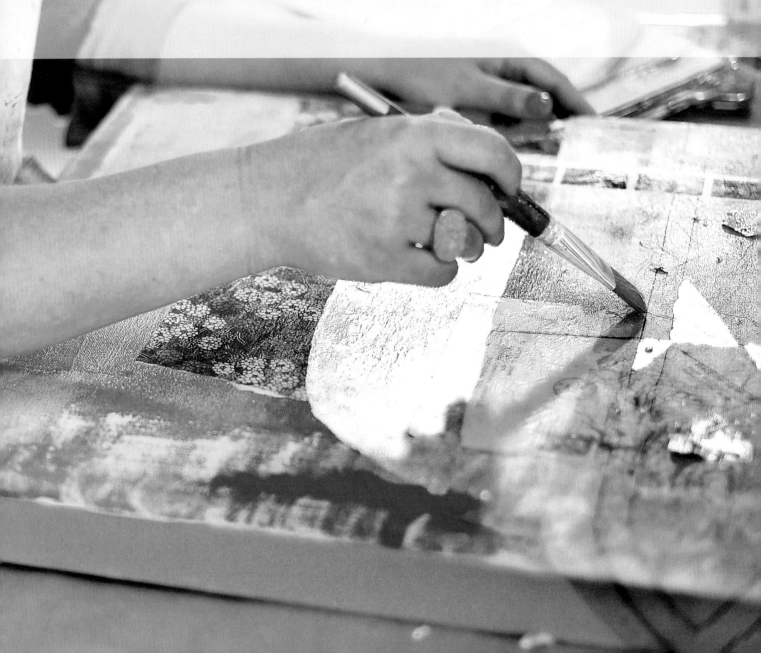

STEP 1

Using your Stabilo pencil, you can sketch over both paper and paint as it works well on a lot of surfaces.

STEP 2

Like you did earlier, you can place the adhesive for the silver leaf inside the sketch.

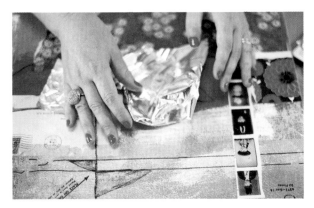

STEP 3

After waiting about an hour for the adhesive to get tacky, place the silver leaf on top and press.

STEP 4

Wipe away any excess silver leaf.

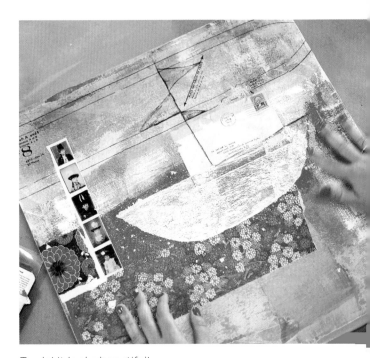

Ta-da! It looks beautiful!

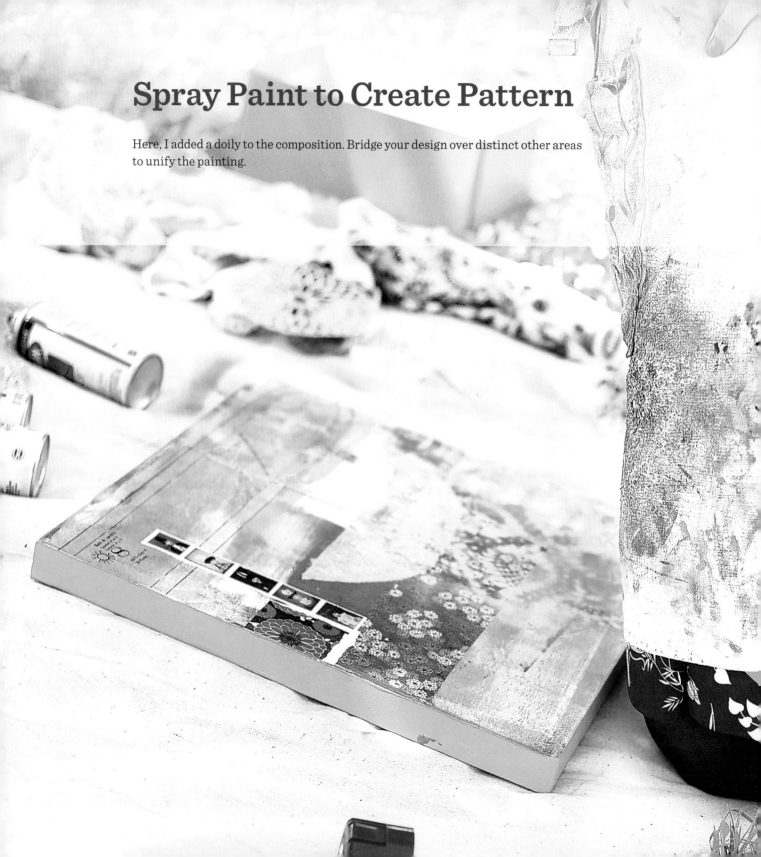

Spray Paint to Create Pattern

Here, I added a doily to the composition. Bridge your design over distinct other areas to unify the painting.

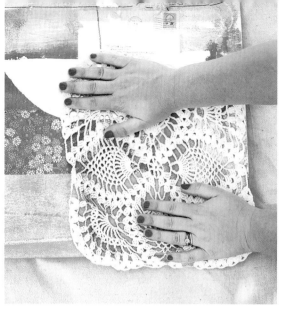

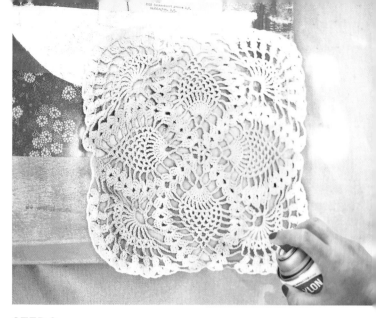

STEP 1

Look at the space you want to cover and survey your options. Choose a doily that is a good size and pattern for the section.

STEP 2

I chose a pale pink spray paint because I think it will offset the rest of the colors in the painting well.

Transfer an Illustration

These photographs demonstrate how to apply a transfer technique to the canvas.
I chose this little fox that I drew in pencil.

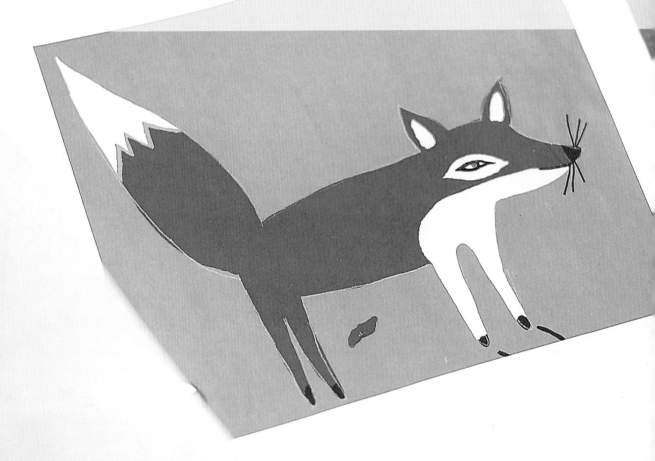

STEP 1
I scanned my fox drawing into
Photoshop and added color.

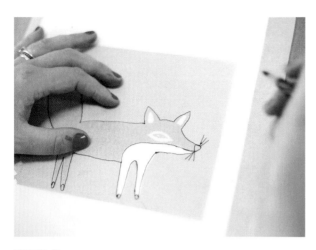

STEP 2

I'm not sure exactly where I want to place the fox on my painting, so I'm using tracing paper so that I can test it out.

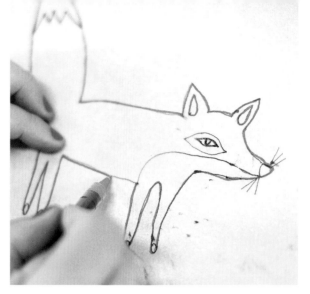

STEP 4

I placed the transfer paper underneath the tracing paper again, making sure that the graphite paper was facing down. (I've made this mistake so many times before where I've put a lot of energy into tracing the outline of the image, only to find that I had the graphite facing up!)

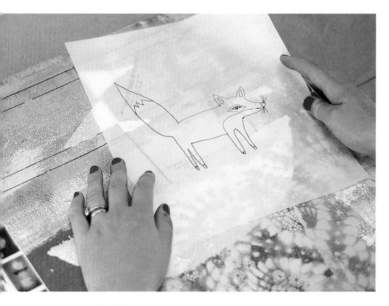

STEP 3

After trying a few different spots, I decided I'd like the fox on the silver-leafed boat.

STEP 5

As you can see, with a textured canvas, as opposed to a firm, wood substrate, the transfer is a bit lighter because you aren't able to bear down as hard on the surface.

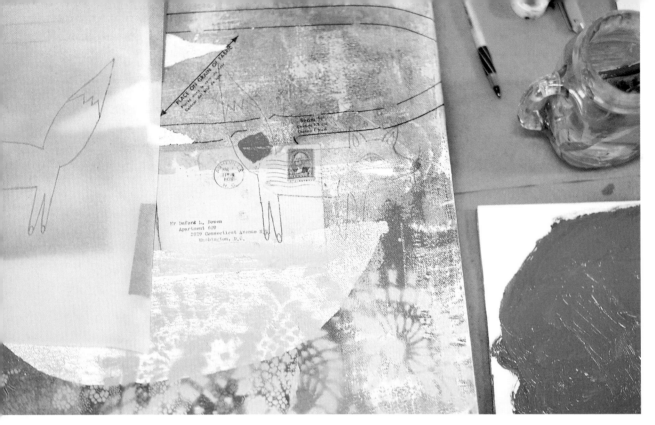

STEP 6

I proceed to paint in the fox, taking into account how he relates colorwise to the rest of the piece. I mix up a burnt orange that shines and plays off the rest of the warm colors in the piece, but doesn't overpower the composition.

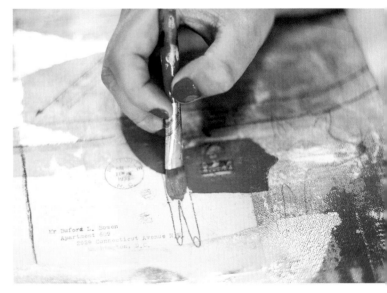

STEP 7

I decided to leave the vintage stamp as part of the fox peeking through under the paint.

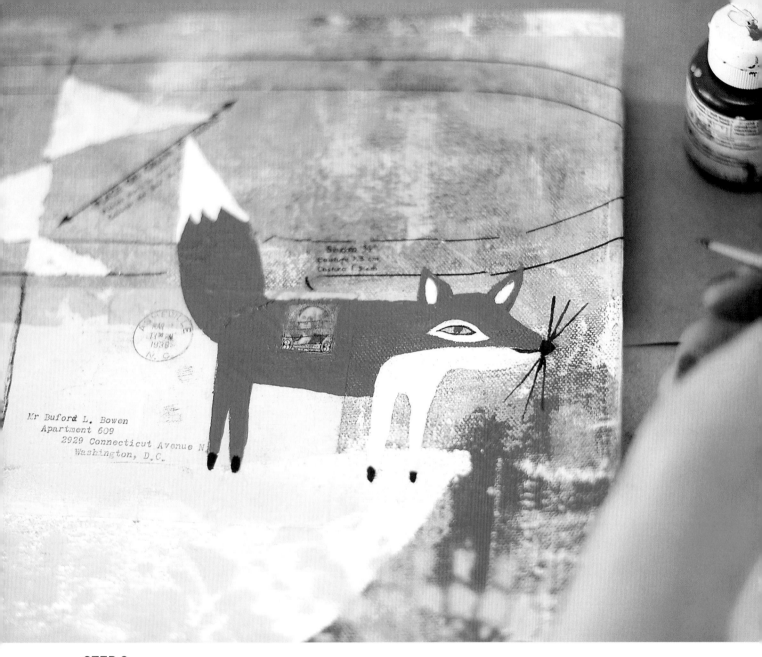

STEP 8

The details of the tail and expression in the eyes and
nose make this fox work. Just as with people, placing
the eyes in a different spot on the face or making them
smaller or larger drastically changes the expression.
Experiment with this! I've found the smaller the eyes,
the sadder and older the character looks!

Invite Collaboration

Artist Hugh D'Andrade adds his design to my canvas. Sketching using a soft pencil, he uses his whole arm so that he can get a nice, smooth, swooping line, versus drawing from his wrist which would result in a tighter angle and less fluid line.

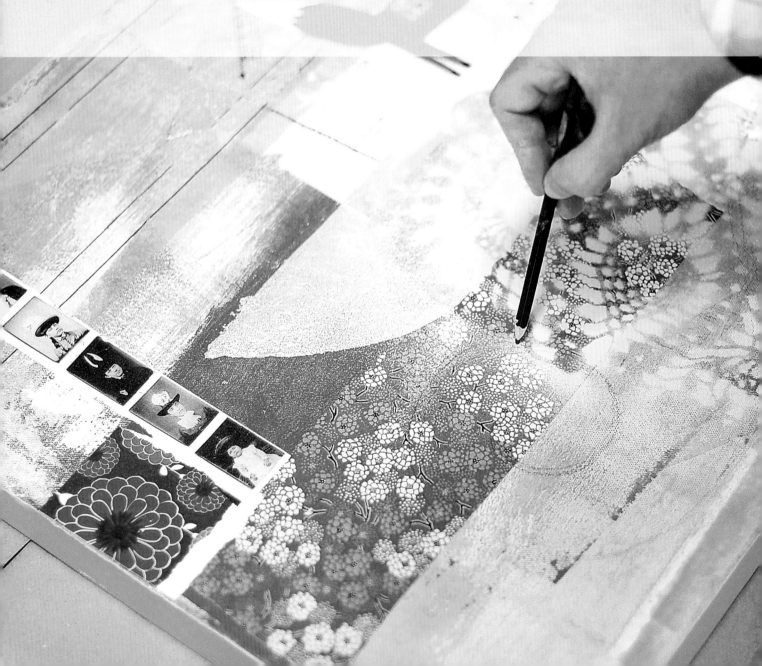

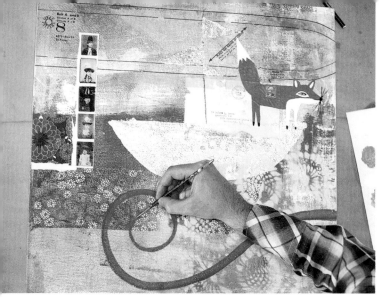

Hugh uses a dark blue paint with lots of Flow Improver to get a nice, smooth line. He uses a couple of coats so that the line is opaque.

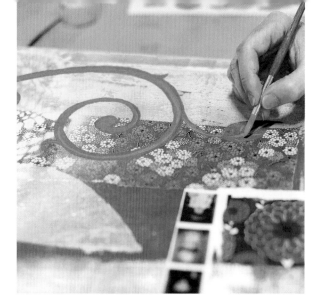

Hugh picked up a lighter version of the same blue just by adding white and then created highlights over the painting.

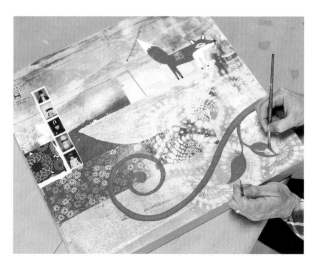

Hugh paints the leaves, stylizing them so the curve of the leaves tapers down to the curve of the vine.

TIP: *If you've never drawn a tree branch before, it's likely you can see one out your window, so practice sketching directly from nature.*

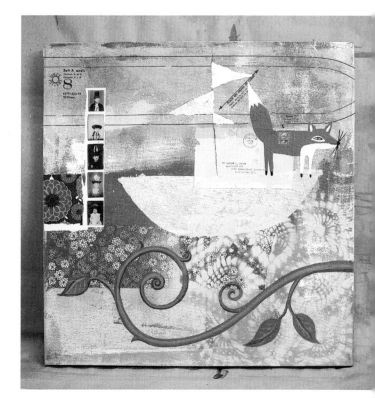

The end result looks good!

Use Photographs to Tell Your Story

One of my favorite photos from my childhood is of my grandfather (whom I called "Papa") and me sailing on his boat, named the *Mati Rose*. I suppose this explains why I identify so much with sailing metaphors and ship imagery!

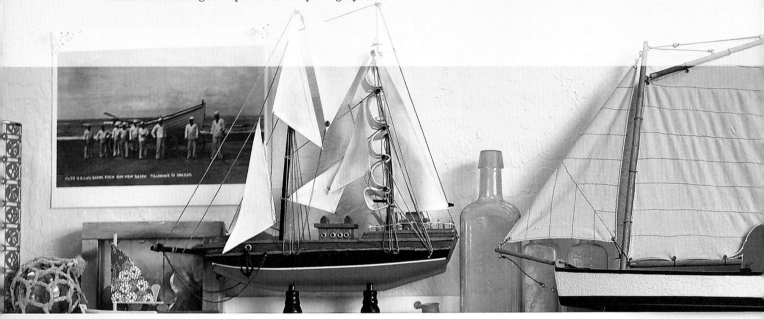

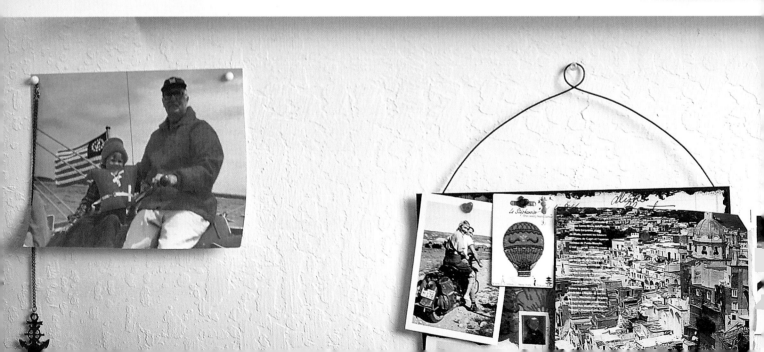

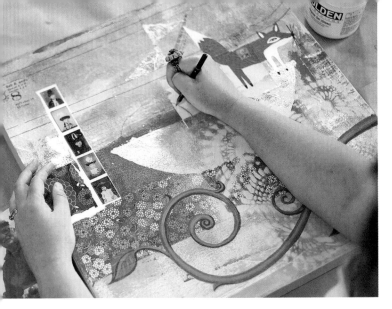

STEP 1

I reference two items, the photo of my Papa and me sailing and a previous painting of mine that is printed on cards. I decide to incorporate an interpretation of myself as a bright orange-clad three-year-old on the silver-leaf boat. I like how, in the card, there is a big half-moon face and I decide to paint myself in that fashion, starting with a pencil sketch.

STEP 2

I draw in the details of the hair and my closed eyes—I like how this looks stylistically.

STEP 3

Choosing some of my favorite patterns from the cards, I cut them into feather shapes and adhere them with gel medium.

LEFT: Here is a collection of model boats, sea inspiration, and a picture of us.

STEP 4

Improvising, I add little half-circle cheeks from a circle cut from a scalloped hole punch. I mix up a flesh tone and fill in the face.

STEP 5

She looks pretty cute already to me, but I painted over the details of her face, so I need to go back in and draw them again.

STEP 6

I add a couple more feathers and, mimicking the photo of me, add an orange cap on her head.

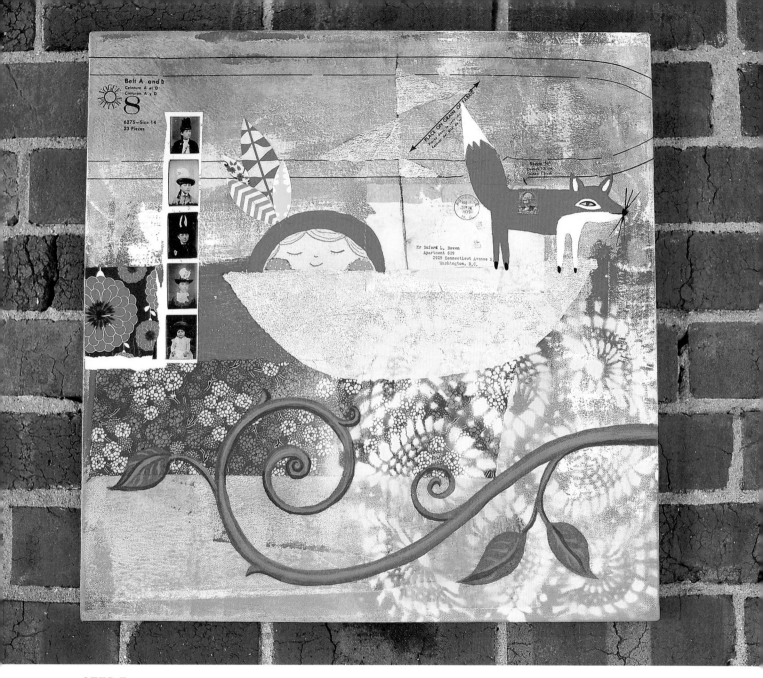

STEP 7

I end up fussing with the details of her face a bit, continuing to paint over it several times with the flesh tones and redrawing the elements of the face, until it looks good, happy, and filled with childlike joy, just like the photo feels to me.

The Evolution of a Painting

In chapter one, we first built up multiple base layers of paint with a brush. We then continued to daringly experiment with the painting, with no idea how it would turn out! Here's an overview of what happened for each layer.

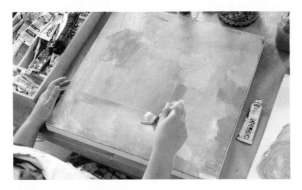

1 First, build up multiple base layers of paint.

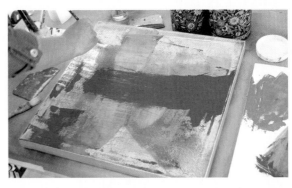

4 Run a dry-brush over it.

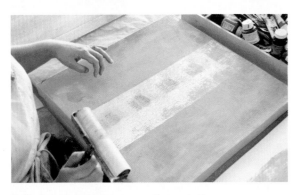

2 Roll your brayer across the painting.

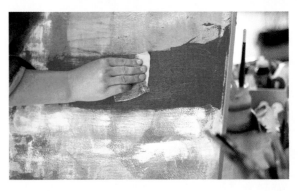

5 Sand it.

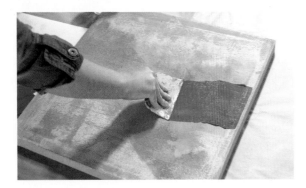

3 Use the squeegee to add color and texture.

6 Put a collage onto it.

7 Apply silver leaf on top of it

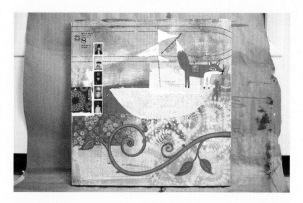

10 Collaborate with a friend.

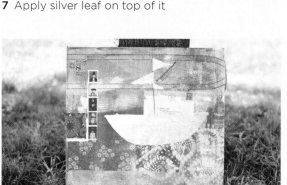

8 Spray paint over it using a doily.

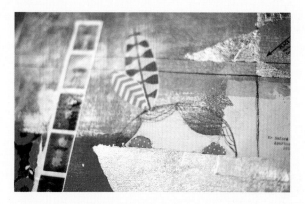

11 Add a personal memory.

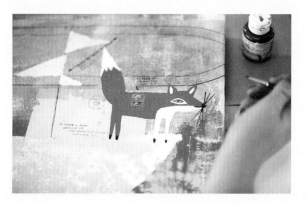

9 Transfer a drawing onto it.

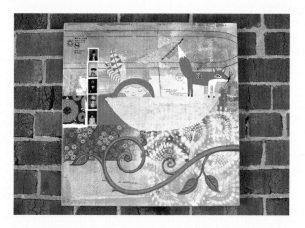

It's a wrap! This painting combines the techniques in all seven chapters, and more.

Resources

Artists

Lisa Congdon
www.lisacongdon.com

Jennifer Judd-McGee
www.swallowfield.typepad.com

Maira Kalman
www.mairakalman.com

Andrea Scher
www.SuperheroJournal.com

Flora Bowley
www.florasbowley.com

Thomas Campbell
www.thomascampbell-art.com

Hugh D'Andrade
www.hughillustration.com

CCA Professor Mark Eanes
www.markeanes.com

Camilla Engman
www.camillaengman.com

Sabrina Ward Harrison
www.sabrinawardharrison.com

Jason Jägel
www.jasonjagel.com

Leslie Sophia Lindell
www.lesliesophialindell.com

Beatriz Milhazes
Represented by the James Cohan Gallery
www.jamescohan.com/artists/beatriz-milhazes

Kelly Rae Roberts
www.kellyraeroberts.com

Lilla Rogers Studio
www.lillarogers.com

Betsy Walton
www.morningcraft.com

Nate Williams
www.n8w.com

Places

Gee's Bend Quilts
www.quiltsofgeesbend.com

Mati McDonough's Studio
www.teahouseartstudio.com

Rare Device
www.raredevice.net

Books

Amy Cutler by Lisa Freiman and Amy Cutler (Hatje Cantz Publishers, 2006)

Brave Intuitive Painting—Let Go, Be Bold, Unfold! by Flora Bowley (Quarry Books, 2012)

Cultivating Your Creative Life by Alena Hennessey (Quarry Books, 2012)

Painted Pages by Sarah Ahearn Bellemare (Quarry Books, 2011)

Robert Rauschenberg: Combines by Robert Rauschenberg, Paul Schimmel (ed.) (The Museum of Contemporary Art, Los Angeles, 2005)

Sabrina Ward Harrison
www.sabrinawardharrison.com
Sabrina is the author of several books. Her first book is titled *Spilling Open: The Art of Becoming Yourself* (Villard, 2000)

Water Paper Paint by Heather Smith Jones (Quarry Books, 2010)

About the Author

Mati Rose McDonough lives in San Francisco where she regularly encounters lucky elephants, talking birds, and a mysterious girl who always wears feathers in her hair. These creatures of mystery and grace remind Mati daily that no one is too old for magic or too young for beauty, so she tells their stories in paint. When she is not covered in paint you can find her biking on her sea foam green bike, drinking tea, and seeking inspiration. It has been a long-held dream of hers to write a painting book and she couldn't be happier than to share it with you.

Mati studied painting at the California College of the Arts and has had numerous shows around the country. She has taught at painting retreats in the U.S. and in Italy. Mati cofounded Teahouse Studios in Berkeley and Get Your Paint On! online painting classes. She is represented by Lilla Rogers Studio in illustration and licensing and has had her art published on Patagonia shirts, University Game boards, Pier 1 products, Calypso cards, Madison Park Greeting products, and Oopsy Daisy canvases. Mati has also been included in several magazines and books including recent features in *Artful Blogging* magazine and *The Handmade Marketplace* book. Find out more about her artwork at her website: www.matirose.com.

About the Photographer

Leslie Sophia Lindell is a food, lifestyle, and travel photographer based in the San Francisco Bay Area. She is all about natural light, atmosphere, and pleasing clients. Great minds, boisterous shared meals, and getting on the next airplane serve as her joy and inspiration.

www.lesliesophialindell.com

Photo: Riley Sykes

Acknowledgments

It takes a village. Thanks to Mary Ann Hall for reaching out to me and helping this book flow so well, even among the tidal waves! And thanks to Betsy Gammons for holding it all together with the Quarry team, Dave and Cora. Leslie Sophia Lindell, you are magic. Thank you teahouse studio mates, Tiffany Moore and Stefanie Renee, who were both incredibly patient and supportive during this process. To Laurie Wagner who helped me lean into my words and coached me through the seedling of an idea to the fruition, and to Willo O'Brien and the SF Ladies Design League (LIDL) who supported me every Monday morning at the Ferry building in my caffeinated state. Thanks to Lisa Congdon who is graciously featured in this book and is my fearless partner in online painting and awesome support in life and art.

My love bombers, especially to: Andrea Corrona Jenkins—for tirelessly going over the photos while sequestered in a room overlooking the Oregon coast. Kelly Rae Roberts—for walking alongside me in art and business and inspiring me to reach higher. Andrea Scher—for Berkeley walks and talks and treasure seeking. Alessandra Cave—for beginnings. My family—Mom, Michael, Andrew, Jesse, and Tom, and the D'Andrades. To Hugh, you will always inspire me artistically. My dad Brian and the McDonough side for passing down my artistic genes, and especially to you, Jamie Hogan. Graphic design wizards Lisa Berman and Claire Moore in the final hour. Kate Walsh-Cunnane for grounded mid-day walks and talks with wee Will. Rebekah Fletcher for being my best friend since age five: I can't imagine my life without you. Lilla Rogers Studio for being an amazing illustration agency and mentor.

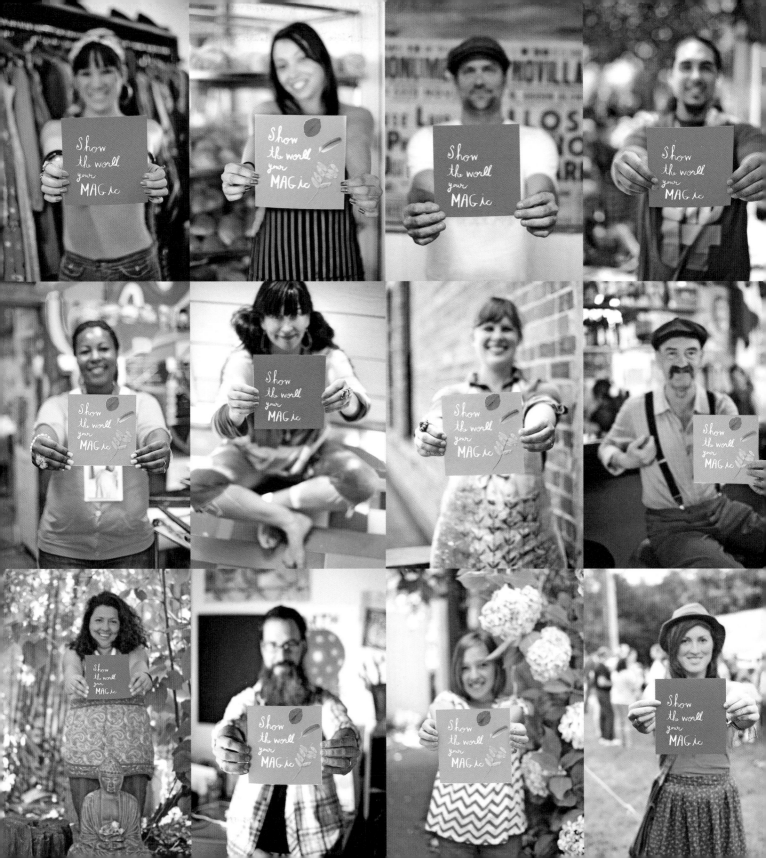